IMAGES
of America

STEAMBOAT
SPRINGS

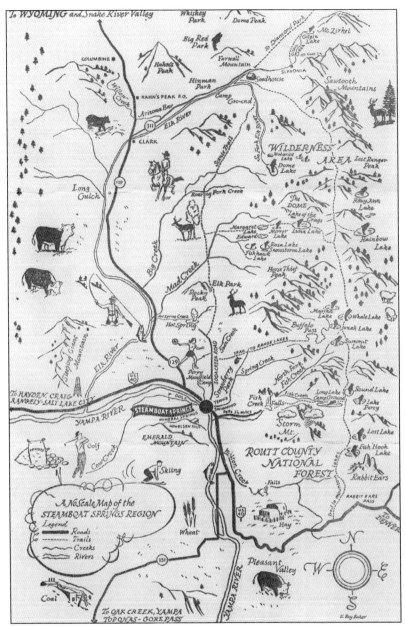

The Steamboat Springs Chamber of Commerce produced this map about 1950 to encourage tourism. Unfortunately, Toponas, to the south, is not shown on the map. Special events included the Fourth of July rodeo, the square dance festival in August, and the Winter Carnival in February. Also advertised was an "Aspencade" to view northern Routt County's spectacular fall scenery. "Summer or Winter You'll Like Steamboat Springs," boasted the brochure. (Ellis collection.)

ON THE COVER: One cold winter morning nearly 90 years ago, F. M. "Frank" Light (founder of Steamboat's centennial clothier, F. M. Light & Sons) and four of his young adult offspring took time to enjoy the firmly packed snow on their "Big Eight" sled. From left to right, family members include Wayne (on back cover), Hazel, Day, Audrey, and Frank. (F. M. Light & Sons.)

IMAGES
of America

STEAMBOAT
SPRINGS

David H. Ellis and Catherine H. Ellis

ARCADIA
PUBLISHING

Published by Arcadia Publishing
Charleston, South Carolina

Printed in the United States of America

Library of Congress Control Number: 2009922887

For all general information contact Arcadia Publishing at:
Telephone 843-853-2070
Fax 843-853-0044
E-mail sales@arcadiapublishing.com
For customer service and orders:
Toll-Free 1-888-313-2665

Visit us on the Internet at www.arcadiapublishing.com

To John Rolfe Burroughs,
who turned the saga of northwestern Colorado into a siren's song.

CONTENTS

ACKNOWLEDGMENTS

Picture in your mind a scene a half-century old: a 10-year-old boy teeters on the threshold of the candy store, nose against the glass. In his hand is the key to the door. That jubilant year was 1955, I was the boy, the key was my soon-to-be muddy feet, the store was the Yampa Valley, and the sweet treats were each bob-o-link and badger, beaver and bittern, fox and coyote, gopher and owl. This book is the long overdue first payment for the sweet treasures given me by the only place I ever felt was truly my home.

Cathy and I offer thanks to all who opened their doors and shared their stories. Special thanks go first to Raymond Gray and his daughter Marsha Daughenbaugh. I hope this book provides recompense for breaking the front wheels off Ray's tractor, rolling his side-delivery rake over a cliff, shooting a hole in his hat, and lots of lesser peccadilloes dating back nearly 50 years.

New and old friends also helped. Jim Stanko, my neighborhood pal and now local historian, provided perspective and family photographs. Deb and Loris Werner opened our eyes to the world of skiing. Annabeth Light Lockhart not only wrote her own book on F. M. Light & Sons but made additional family photographs available. Janice Kay and Zelma Nash of Columbine, Hildred Fogg of Yampa, Wanda Redmond of Toponas, John Cappell of the Yampa Valley Electric Association, Linda Long of Oak Creek, and Mary Pat Dunn at the Hayden Heritage Center graciously shared photographs and information. Mike Yurich at the Tracks and Trails Museum patiently interpreted early coal mining. Daniel Davidson and Janet Gerber of the Museum of Northwest Colorado (Cowboy and Gunfighter Museum) at Craig freely gave time and photographs.

But Steamboat's most important collection of photographs is at the Tread of Pioneers Museum. We offer a special thanks to Candice Lombardo for supporting this project. We have deposited a list of sources for our text there. We encourage all to enjoy the history of Steamboat Springs through the permanent and changing exhibits at the Tread of Pioneers Museum.

INTRODUCTION

Snow, snow, then more snow. Between October 2007 and April 2008, four hundred and eighty-nine inches (41 feet), fell at mid-level on Mount Werner above Steamboat Springs, Colorado. There were 57 powder days (each with 4 or more fresh inches) in a single winter. Snow, bane and blessing to the ranchers in the valley below. Snow, the answer to the supplications of skiers across America and around the world.

Yet there is so much more to Ski Town, U.S.A. than snow. Steamboat environs include verdant valleys, towering mountains, a hundred glacial lakes, mineral springs, two boulder-strewn rivers hiding fat trout, and willow-lined streams crossing rich meadows. In midsummer, the aspen groves are profuse with flowers. Tall larkspur and oversized lupine mix with monkshood and geranium. Then, to crown it all, blue columbines rise, delicate and complex, named for the inverted blossom resembling a small flock of azure doves (*columba* in Latin). And, when the flowers fade, the mountains portend the coming snows by turning scrub oak to scarlet and aspen to gold.

The woods and meadows, however, would be a mausoleum but for the flash of butterfly wings and the song of a hundred birds. The bald eagle has returned to the gallery forests along the rivers, and the meadows echo again with the calls of goose and crane. The golden eagle has ever bent his pinions against the rushing mountain air, and the heron colonies provide a raucous serenade at river's edge.

Earth-bound creatures are also here, often in profusion. Most conspicuous to the ear are the tiny spring peepers (frogs), but marmot calls also rend the air. Among the cliffs that ring the Flattop Mountains, you are seldom out of earshot of a marmot colony. The brushlands abound in mule deer, and elk haunt the forest shadows. The wolf and grizzly bear are temporarily gone, but the moose are beginning to return, as are the otter. Beaver and muskrat own the waterways and share their home with trout and whitefish. The white hare and blue grouse share the dark forest.

From peering into the twilight between legend and history, it is certain that the Utes were not alone. For generations, they came to gather the abundance of summer while camped among the warm mineral springs. But Arapahoes, seeking loot, glory, and revenge, sometimes crossed the Park Range (reportedly via Buffalo Pass), attacked the Ute, did as much damage as they could, then returned to their domain in North Park. The local Utes, the Yampatikas, mostly wintered along the Colorado River to the south and southeast of Toponas and in Middle Park. Perhaps the most important wintering area for the northern Utes was Brown's Hole or Brown's Park along the Green River about 12 miles above its junction with the Yampa.

Evidence that ox-drawn wagons had visited the Yampatika decades before the first permanent settlers comes from the finding of a wooden ox yoke thoroughly grown into the crotch of a long-dead cottonwood tree near the springs. This mystery was likely explained by the journals of Isaac Miller, a boy of 16 in 1849, when his wagon train turned south into the mountains to recruit their oxen and other livestock near some hot springs, including one that made a chugging sound. After several weeks, the train headed north to continue its journey to California.

Between 1820 and 1875, there are records of a half dozen other exploration parties traversing the Yampa Valley. The Lord Gore Expedition (Sir George Gore of Ireland for whom Gore Pass is named) of 1854–1856, an almost unprecedented saga of wildlife slaughter, opened a primitive road into the Yampa country from Middle Park.

Long before the Utes were gone, a sizeable cattle industry was developing on public lands. With the Gold Rush of 1849, California began to fill with people who wanted beef. Longhorns, descendents of Andalusian cattle from southern Spain, were driven by the thousands from depleted ranges in Texas and Louisiana to the sparse western plains and onward to the lush pastures of the mountain west. Their trail led north to the Platte, then west through the sagebrush hills where the Continental Divide is low and easily crossed. On such long drives, the cattle bosses needed a place with tall grass and short snows to winter their cattle. Beginning in 1850, Brown's Hole served this purpose.

The eastern cities also craved flesh, and northwestern Colorado, with its juniper- and sagebrush-covered hills, provided for the cattle in winter, while the abundance of snow in the high mountains translated into pasturage in an almost unbelievable profusion over a huge area, from Bear Ears and Baker's Peak east to Hahn's Peak and south through the Park Range, then west through the Flat Tops and north again to Bear Ears. During the era of the cattle barons and before overgrazing sapped nature's bounty, more cattle were shipped to market from these summer and winter ranges than from anywhere else in America.

During the era when cattle ranged free on public and railroad lands, certain processes commenced that spelled doom for the big cow outfits. First, and most importantly, the productivity of the land collapsed before the onslaught of too many mouths and four times too many hooves. It was the oft-repeated story: "the tragedy of the commons." Simultaneously, water resources for the cattle and sheep, especially in the drier lands where the livestock traditionally wintered, were patented and fenced by homesteaders and small ranchers. With the dawn of the 20th century, the federal government got involved trying to save depleted lands from erosion and overuse. First came the national forests and later the Bureau of Land Management, both limited grazing to allow the ranges to recover.

But settlement of the Steamboat Springs area came earlier. James H. Crawford first visited the springs in 1874 and returned with his family in 1875. The Crawfords fished, hunted, and learned to survive the harsh winters. Miners had already come to prospect the Hahn's Peak area by the time of the Civil War. Later Oak Creek was established as promising beds of coal were found in the hills south and west of Steamboat Springs.

The defining feature of Steamboat Springs is not the plethoric snow, the whispering pine, or somber spruce, but the rush of scented water from caverns deep in the earth. To some noses, the sulfur springs would have been ample excuse to homestead elsewhere. But there are many non-sulfurous springs, and some are so warm, and Steamboat is often so cold, that pioneer settlers could nestle their homes near the warmth of other sweet-smelling springs. In the early 20th century, various tourism-inspired enterprises sought to develop the springs as health spas, but only the swimming pool paid off.

The people of the Yampa and Elk River Valleys knew they lived somewhere special, and thankfully they recorded their history in photographs, which their children preserved for us today. This book is about people: hardy, charismatic, felonious, virtuous, athletic, idiosyncratic, and sometimes all six. It is also about the sublime setting: a place rife with bubbling hot springs, soaring mountains, and two silver threads—the Yampa and the Elk Rivers—which weave a living tapestry through meadow and grove.

One

Ski Town, U.S.A.

The town of Steamboat Springs, Colorado, at an elevation of 6,795 feet, is nestled between mountains that rise to more than 10,000 feet. Skiing played a huge role in the founding of Steamboat and many other mountain towns in Colorado. Strange as it may sound in today's world of asphalt and internal combustion engines, in former times and in some areas, it was actually easier to travel in winter than in summer. Marco Polo, the Venetian, reported that the vast expanse of Siberia, although a morass in summer, was readily and frequently penetrated in winter. In 1874, when James Crawford, Steamboat's founder, visited the springs, he had to leave his cart many miles to the south. When he returned to secure his home site in 1875, he came on skis.

Much of the story of Steamboat Springs is about winter. Colorado knew many skiing postmen and a few skiing parsons. Today it seems incredible that the mail route from Steamboat to Georgetown was covered on skis. Eventually skiing became sport, and Steamboat Springs organized a Little Toots Ski Class for four and five year olds. Ski classes were taught as part of the high school curriculum as early as the mid-1940s, a first in the state. Beginning in 1935, the high school band performed on skis, and in 1950, they put skis on rollers so they could "march" in a parade in Chicago in summer. The Winter Carnival in February includes miscellaneous ski races for children. Ranching traditions were combined with winter sports by including skijoring (skiers pulled by horses or sometimes automobiles) and the diamond hitch (skijoring with four skiers forming a diamond).

With such emphasis on winter sports, Steamboat Springs naturally produced an inordinate number of national champions and Olympians. The U.S. National long distance ski-jumping record was set at Steamboat nine times between 1914 and 1980. The label, "Ski Town," was first applied nationally by the Associated Press in 1947. "Ski Town, U.S.A." appeared as a title in 1950 when Steamboat's ski band participated in the International Lions Club convention in Chicago.

If a single image can typify winter in the high mountain valleys of Colorado, this is a good candidate. Long touted as the most successful ski poster ever published, this image, captured by Gerald Brimacombe on a cold (minus 20 degrees Fahrenheit) January morning in 1970, shows ski instructors Rusty Chandler (left) and Jo Semotan breaking trail on Pine Grove Road near Steamboat Springs. (Steamboat Ski and Resort Corporation.)

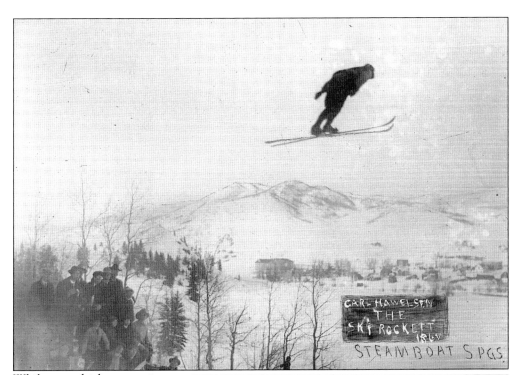

While many high mountain towns organized races for fun during the closing decades of the 19th century, credit for founding sport skiing in Colorado goes to Carl Howelsen (P. T. Barnum's "Flying Norseman"). Howelsen (above) came to Steamboat Springs in February 1913. He soon changed skiing from being merely a mode of transportation to a fun pastime. He taught community members to make skis from better wood (maple or hickory), to groove and wax the skis, and to use shorter poles. He built the first ski jump on the hill south of town, and in return, the community renamed it Howelsen Hill (right). (Above, Museum of Northwest Colorado; at right, Loris and Deb Werner.)

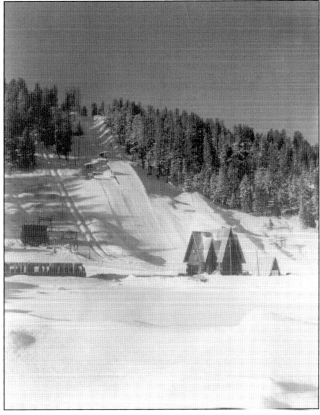

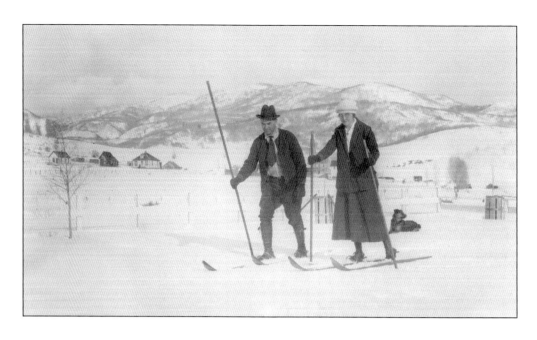

In the late 19th century, skis were clumsy affairs, bindings were tenuous, and people mostly used one pole. In fact, skis were not even called skis. They were called Norwegian or Swedish snowshoes. The word "ski" derives from Norwegian *skiboler*, literally "ski boards." Early boards were not even the same size. Skiers steered with the short board. The 6-to-8-foot pole was straddled and, on very steep slopes, used as a continuous brake. In both of these photographs, one man uses a single pole, although not between his legs. Pictured above are Clarence and Anna Light. Their daughter Annabeth Lockhart noted that the Light family enjoyed outdoor activities, including skiing and ice-skating. Below, Ed Stevens (left) and Lawrence Juel are skiing at Columbine in November 1940. (Above, F. M. Light & Sons; below, Janice Kay.)

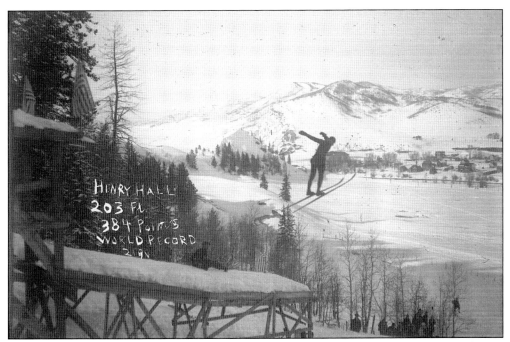

With National Ski Association affiliation in 1916, Steamboat Springs began hosting official jump competitions. Many early ski-jump records were set at Howelsen Hill. Above, Henry Hall is setting a national jump record of 203 feet in 1917. Below, Anders Haugen jumps at the same event (note the town of Steamboat in the background). Hall and Haugen were part of a group of semiprofessionals who regularly competed in Steamboat. Others in this group included Hans Hansen, Lars Haugen, and Ragnar Omtvedt. Anders Haugen was twice an Olympian (1924 and 1928). These photographs are part of a series of glass plates made in 1917. (Both Museum of Northwest Colorado.)

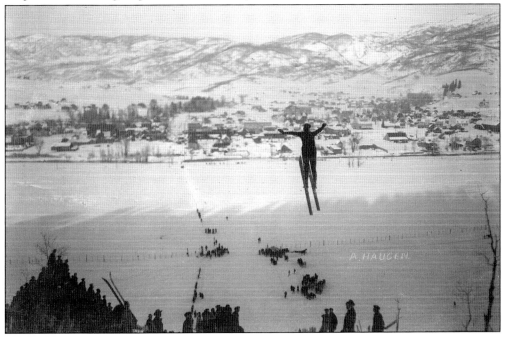

Dorothy Wither's priceless collection of early Steamboat photographs led to the founding of the Tread of Pioneers Museum in 1970. She also operated the Dorothy Shop and was involved with every aspect of winter sports. Sureva Towler called her "The First Lady of Steamboat Springs" and noted Wither's "respect for the past and enthusiasm for the future." (Tread of Pioneers Museum, Steamboat Springs, Colorado.)

Marjorie Perry loved the outdoors, skiing in particular, and rode horseback from Steamboat to Denver 13 times. She was instrumental in bringing Carl Howelsen to Steamboat in 1913, and, with his help, the first Winter Carnival was a great success. Pictured here are Howelsen (second from right) and Perry (second from left) about 1915. (Tread of Pioneers Museum, Steamboat Springs, Colorado.)

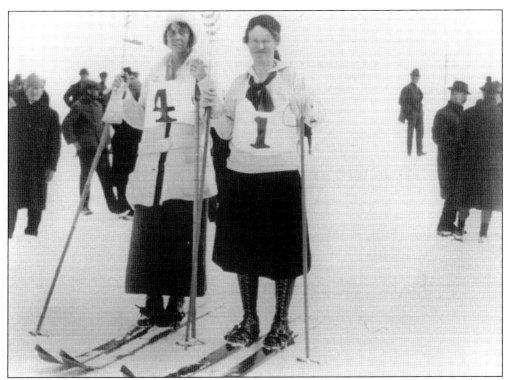

The ladies quarter-mile free-for-all race in 1914, seen above, was won by Margaret McPhee of Denver, with Marjorie Perry (right) coming in second. The *Routt County Sentinel* reported that "Routt county has dozens of young ladies who are experts on the long pieces of wood." Below, about 1925 in Yampa, are three of James and Lillian Alfred's children. From left to right are Lee, Betty, and Elmer, ready for a winter outing. Marcellus Merrill remembered that the Alfred ranch was "the last large ranch before you passed that valley that took you up to the center of the Flattops, one of the most beautiful group of mountains, I believe, in Colorado." The Alfred table always had a place available for a traveler. (Above, Tread of Pioneers Museum, Steamboat Springs, Colorado; below, Hildred Fogg.)

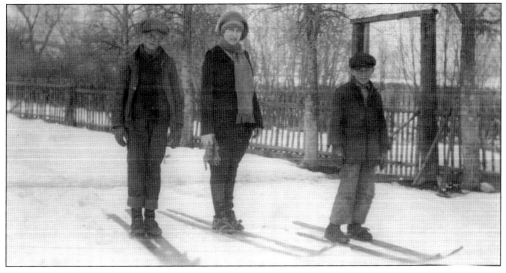

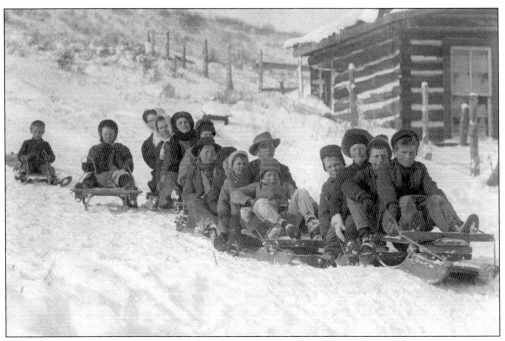

Sledding was fun for both young and old. Here are some of the citizens of Yampa on their special hill for sledding. Today sledding has evolved into the luge Olympic event. Jim Murry, a Steamboat Springs resident, was on the U.S. Olympic luge team in 1968, 1972, and 1976. He coached the U.S. luge team in 1980. (Hildred Fogg.)

Steamboat Springs has the reputation of children being able to ski as soon as they can walk. Wallace "Buddy" Werner was on skis before he was two years old. Some children, too small to ski, were carried when their parents were cross-country skiing. Jan Leslie is bundled up in 1939 ready for a ride in her perambulator-on-runners. (Tread of Pioneers Museum, Steamboat Springs, Colorado.)

In 1957, Audrey Temple, Donna Struble, Pat Green, Doris McNeill, and Frances Nash formed the Little Toot ski program for their preschool children. They hired Crosby Perry-Smith to give the children lessons and arranged competition and prizes. At right is a boy, identified as No. 172 (possibly David Baldinger), on skis in February 1970. Below, Leon Shopp and his sheep participate in a parade in 1979. (Both Tread of Pioneers Museum, Steamboat Springs, Colorado.)

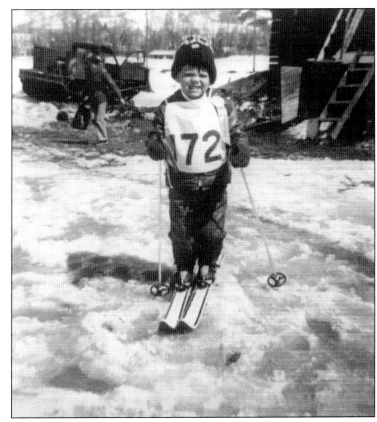

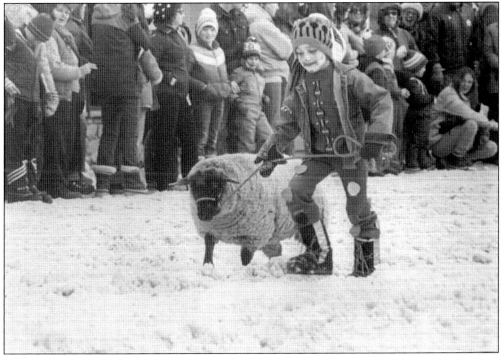

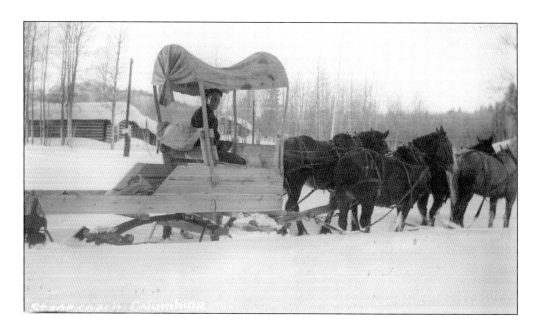

Today the term "stagecoach" conjures images of an enclosed wheeled carriage, but for much of the year in snowy northwestern Colorado, modifications were necessary. Sometimes the stage's wheels were replaced with runners and other times it had both wheels and runners, using whichever method best met the snow conditions. Two stages are shown here at the high mountain village of Columbine. Above, Cyrus Hartzell drives the horses during the winter of 1939–1940. Below, Burkie Byer has a loaded stage with Norris Durham (left) and Janice Juel standing nearby. (Both Janice Kay.)

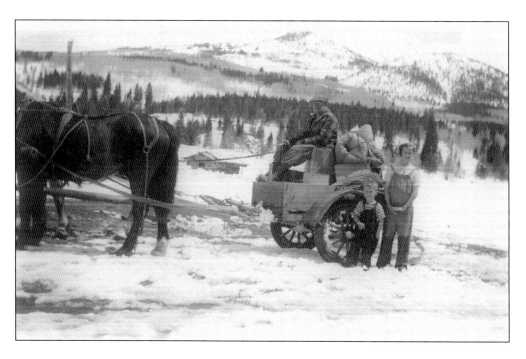

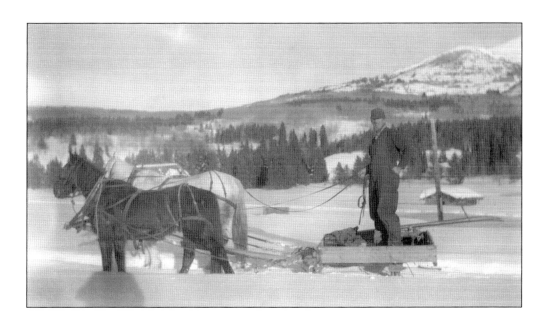

Two 1940–1941 stages are illustrated here. Above, James Zimmerman is at the reins, and below, from left to right, are Elmer Ireland, Cecil Atkinson, Jack ?, and John Gill. Many a tale could be told of the horses and men who fought steep hills, deep snow, and the morass of spring to haul people and packages in these mountains. But nothing surpasses Logan Crawford's wild ride with Billy Eickoff as they risked life and limb transporting four zoo-bound, half-grown mountain lions from Steamboat to the railhead at Wolcott. At every stop, the sleigh was one to two hours early. The horses surpassed all previous efforts as they raced to escape the lion scent strapped to the sled behind. Mail would wait another day as astonished homesteaders stood, letter in hand, at trailside when the terrified team swept past—$50 each for four lions could not be denied. (Both Janice Kay.)

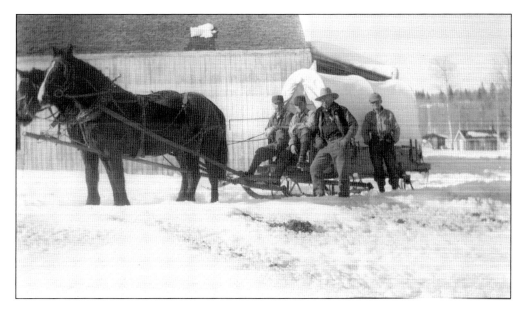

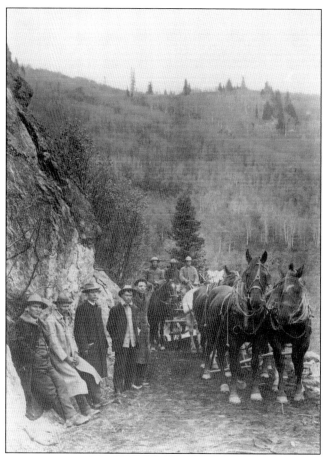

Named for its distinctive rock outcrop, Rabbit Ears Peak, below, reaches an elevation of 10,654 feet. The photograph at left shows the county commissioners and mayor of Steamboat who traveled by automobile to Rabbit Ears Pass on October 9, 1913, to view the progress Harry Ratcliff had made in road construction. From left to right are William Cawlfield and Charles Franz (county commissioners), Fred A. Metcalf (mayor), Harry Ratliff (forest supervisor), Jim Reynolds, Stanley Brock, Van Trullinger, and Luther Lee. The *Routt County Sentinel* reported the men were "amazed that such a road could be built in such a short time over a pass on the Continental divide." The road over Rabbit Ears Pass opened for summer traffic in 1914. (At left, photograph by J. R. Francis, Hayden Heritage Center; below, Ellis collection.)

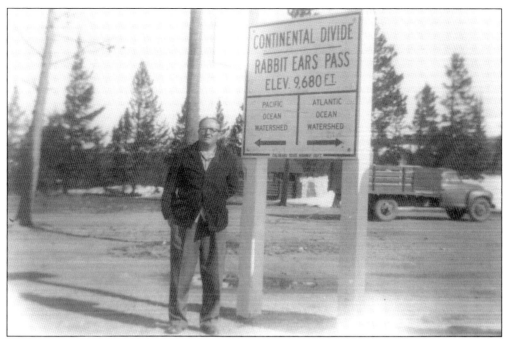

Rabbit Ears Pass (the road now crosses at 9,426 feet) straddles the Continental Divide. In 1952, this unidentified man posed at the watershed sign. Snow melt from the west side empties into the Yampa River, which empties into the Green River, the Colorado River, and the Gulf of California. East of the pass, water enters North Park, which is drained by the North Platte River, emptying into the Missouri River, the Mississippi River, and finally the Gulf of Mexico. Below left, a little girl stands on the road by a deep bank of snow typical of Rabbit Ears Pass in winter. The companion photograph, below right, shows it was actually late spring. The road was first plowed for the Winter Carnival in 1936, but a snowstorm still prevented automobile traffic. In the early days, local businessmen were required to help clear the drifts. (All Ellis collection.)

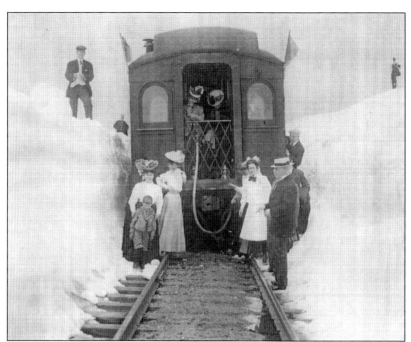

When the railroad reached Steamboat Springs in 1908, winter travel became much easier, at least when the tracks were plowed. Early trains often stopped on the mountain passes to allow passengers time to enjoy the deep snow (above). The first snow train to Steamboat, a train specifically dedicated to snow fun, was an overnight Pullman with dining car. It brought 100 passengers to the 23rd annual Winter Carnival in 1936. Later snow trains included ski experts who gave passengers tips on ski-waxing techniques and other ski-related items. Snow trains were met at the depot by a special sleigh (below), which carried the visitors to their hotel. These special trains were discontinued in 1966. Visitors now arrive by air or road. (Both Steamboat Springs Arts Council.)

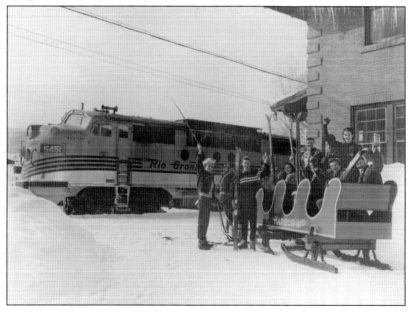

The slopes and amenities have continuously been upgraded by businessmen and skiers at Steamboat. This boat tow was first used in 1938. It was operated by the engine from a Model T Ford and lifted skiers 500 feet uphill. The boat tow returned to the base of the hill by gravity and could carry about 100 skiers each hour. (Hildred Fogg.)

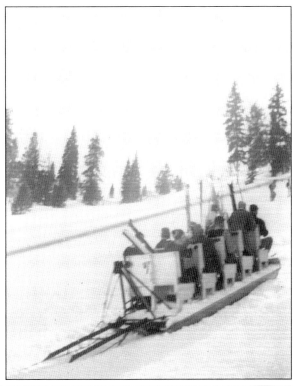

The name Thikol is generally associated with the military and space programs. However, Thikol also made snow cats, useful in maintaining ski slopes. The annual spring training for maintenance crews in the 1960s led to an annual Thikol Rodeo. Here these wide-track machines are being paraded down Lincoln Avenue for all to admire. (Tread of Pioneers Museum, Steamboat Springs, Colorado.)

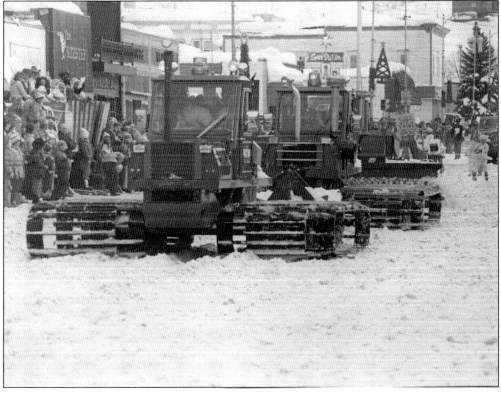

In 1935, public school music teacher Jerry McGuire convinced band members to try "marching" on skis. With practice, it proved possible, and soon the band could both execute their moves and play their music. The Ski Band has ever since led each Winter Carnival parade in Steamboat and is the only ski band in the United States. Above is clarinetist Annabeth Light in the foreground. Pictured below is the band in February 1941. Not seen in the photograph is their white dog, which was trained to "march" with them. (Above, Annabeth Lockhart; below, Museum of Northwest Colorado.)

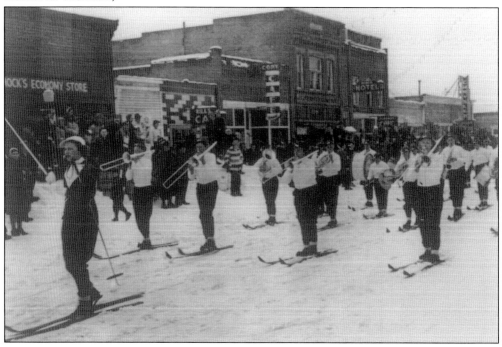

Ironically the most famous photograph of Steamboat's Ski Band is from Chicago. Dressed in red and white, they rolled down Michigan Avenue on July 17, 1950, on white skis with special rollers designed for them by Marcellus Merrill, Steamboat's best-known inventor. The parade was for an International Lions Club convention. It was the only time the band performed on pavement. (Museum of Northwest Colorado.)

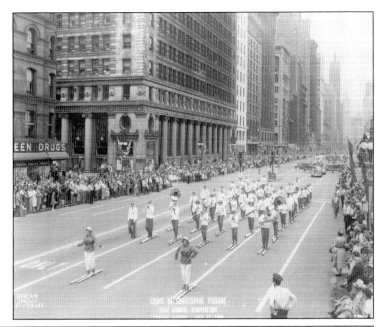

Steamboat was the first town in Colorado to have a ski program in their public schools. It began in 1943. However, a High School Ski Club (for boys) had been organized in 1917, and a Girls' Ski Club was organized in 1931. Pictured here is a 1942 ski team. From left to right are Keith Wegeman, ? Scoggin, Gus Luckins, Jim Cline, Howard Mosher, Bill Gear, Floyd Mosher, Gene Miller, Al Wegeman, Betty Helm, Doris Birkett, Audrey Light, Dorothy Wegeman, Kneeland Light, John Eliott, and Gene Rolston. (Hildred Fogg.)

Although Hot Sulphur Springs hosted a winter carnival two years before Steamboat (1912), Marjorie Perry and Carl Howelsen helped Steamboat follow suit in 1914. The Winter Carnival, now held the second week in February, includes three types of competition: ski jumping, cross-country racing, and street events. Above, locals and visitors line up to see the cross-country race in 1988. At left, Olympians, brothers, and local heroes Loris (left) and Buddy Werner "catch air" at Sun Valley, Idaho, in 1956. (Above, Raymond Gray; at left, Deb and Loris Werner.)

One Winter Carnival event is skijoring, where skiers are towed behind a horse. This was a natural outgrowth of the need in isolated mountain ranches to transport children to school; one horse could tow all of the children simultaneously. A variation, the diamond hitch (pictured here), began in 1927. One horse and rider pulled four costumed skiers holding the points of a rope loop to make a diamond. (Tread of Pioneers Museum, Steamboat Springs, Colorado.)

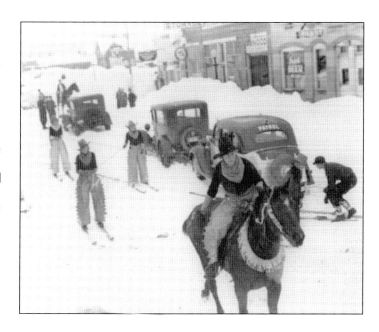

In 1956, ranchers from Baggs, Wyoming, introduced cutter racing to northwestern Colorado. In the first Steamboat competition, in 1957, John A. "Doc" Utterback (local veterinarian, politician, and often winner) ran off the end of the airport runway into the city dump. Wheels were added in 1963 to make chariot races; the original vehicles were made from 50-gallon oil drums. Walt Wheeler is seen here racing in 1987. (Raymond Gray.)

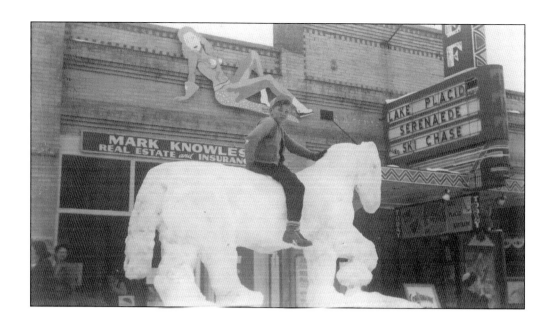

Snow sculptures were part of Winter Carnival from 1929 to 1960 and then were reintroduced in 1972. Part of their popularity, as remembered by Hildred Fogg, was that children got out of school to work on them. In 1945, an unidentified boy (above) sits astride a horse in front of a theater playing *Lake Placid Serenade*, a glittery, Cinderella-on-ice-skates musical released only two months earlier. Many of the sculptures in the 1940s had military themes, including an airplane and a jeep complete with two soldiers sporting helmets and guns. Continuing with the war theme, in 1946, a battleship was constructed on the courthouse lawn and christened the USS *Steamboat* (below). (Above, Hildred Fogg; below, Tread of Pioneers Museum, Steamboat Springs, Colorado.)

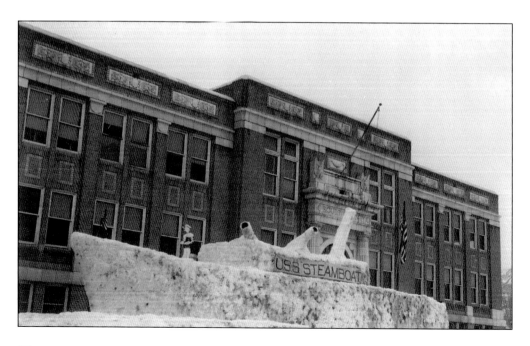

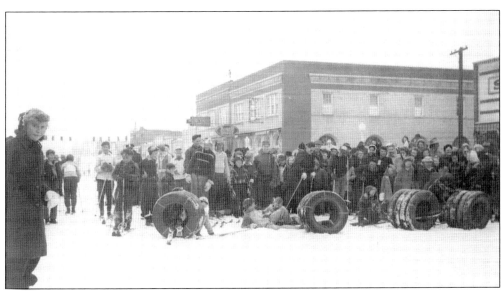

Skiing through a barrel has been part of the Winter Carnival children's competition since 1930. Sureva Towler wrote about that year, "A barrel was disassembled to free two fat boys who attempted to ski through at the same time." The photograph above shows four sets of tires fastened together for children to ski through in the 1940s. At right, Buddy Werner, age eight, emerges from his barrel around 1944. (Above, Hildred Fogg; at right, Tread of Pioneers Museum, Steamboat Springs, Colorado.)

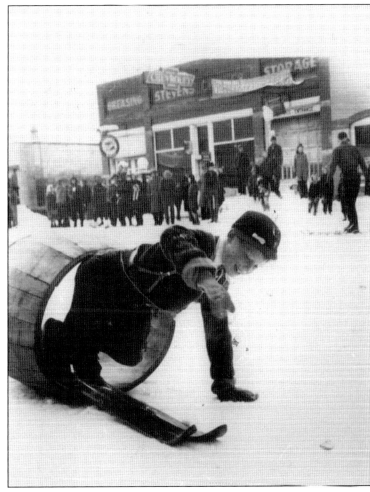

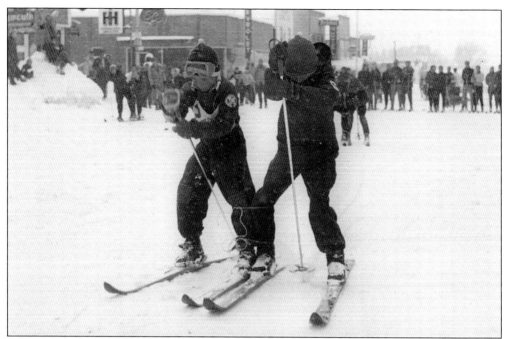

Two races held during Winter Carnival are illustrated here. Above are two contestants in the three-legged race. Teamwork was imperative to ski down the street with their two legs tied together. Below, Boy Scouts are lined up to begin the tent and sled race in 1932. Working in teams of two, the boys skied one block pulling their sled and tent, then set up the tent, and returned to the starting line. Other Boy Scout activities included early automobile skijoring and cross-country skiing. In 1932, Scouts were pulled in eight diamond hitches (32 scouts total) behind two Model A Fords. A 1918 cross-country trek involved 56 scouts led by Vern Soash over Four Peaks to Buffalo Pass. (Both Tread of Pioneers Museum, Steamboat Springs, Colorado.)

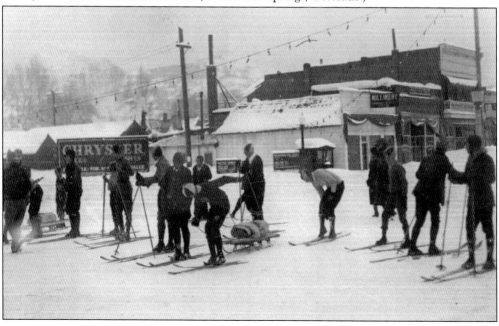

Steamboat Springs often had novel competitions during Winter Carnival. Although the closest thing to jousting was skewering a hoop while skijoring, this "knight and horse" in the c. 1950 image at right may be doing battle with a similarly dressed opponent. Below is a football game on skis in 1945. LeRoy Mills played in this game and that same year, in another event, caught the greased pig while on skis. (At right, Tread of Pioneers Museum, Steamboat Springs, Colorado; below, Hildred Fogg.)

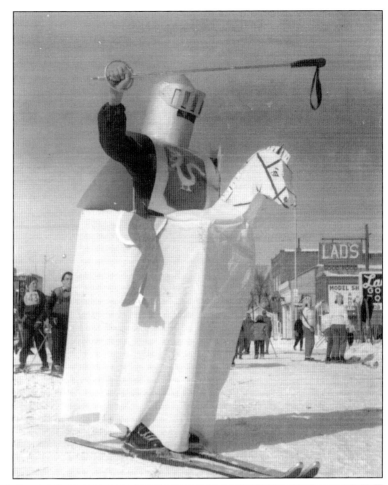

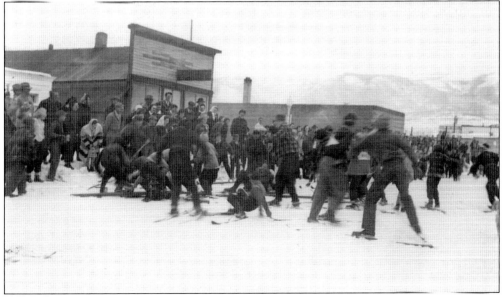

Hazel "Hazie" (left) and Edward "Pop" Werner may have been the quintessential ski parents, willing to support their three children (all Olympians) in ski-related endeavors. They were also area ranchers, first located south of Steamboat and later on the Elk River. Pop was president of the Winter Sports Club and a jumping judge (below with son Buddy). Hazie moved into Steamboat so her children could attend school and worked to support the family, particularly at the Winter Sports Club concession stand with her brother-in-law and sister. She began skiing at age 62, and today the restaurant atop Mount Werner (formerly Storm Mountain) is called Hazie's. (Both Loris and Deb Werner.)

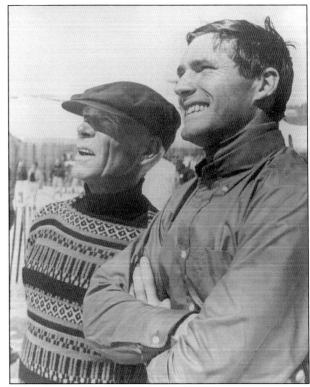

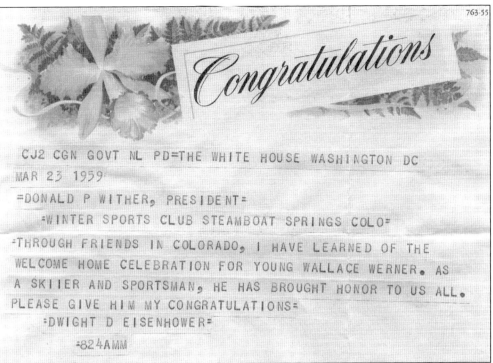

```
CJ2 CGN GOVT NL PD=THE WHITE HOUSE WASHINGTON DC
MAR 23 1959
=DONALD P WITHER, PRESIDENT=
  =WINTER SPORTS CLUB STEAMBOAT SPRINGS COLO=
=THROUGH FRIENDS IN COLORADO, I HAVE LEARNED OF THE
WELCOME HOME CELEBRATION FOR YOUNG WALLACE WERNER. AS
A SKIIER AND SPORTSMAN, HE HAS BROUGHT HONOR TO US ALL.
PLEASE GIVE HIM MY CONGRATULATIONS=
    =DWIGHT D EISENHOWER=
      =824AMM
```

In 1956, Buddy Werner and his sister Gladys "Skeeter" Werner skied for the U.S. Olympic team. Their brother, Loris, skied for the United States at Grenoble in 1968. In 1959, when Buddy was winning competitions away from Steamboat, Don Wither, president of the Winter Sports Club, received the telegram pictured above from Pres. Dwight D. Eisenhower, sending his congratulations. After a career of ups and downs, Buddy decided in 1964 to retire and finish college. He was considered the best alpine skier in America, so his death in a Swiss avalanche that year was a shock. The high school used the photograph at right in their yearbook dedication to him and wrote, "A great athlete; a fearless competitor, a gentleman of highest esteem; truly the finest ambassador the sport of skiing has ever had." (Both Loris and Deb Werner.)

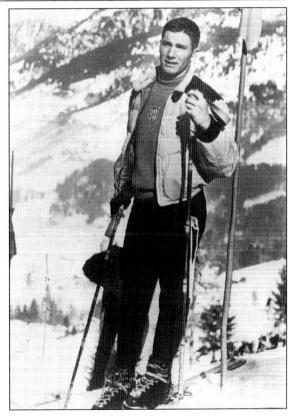

Steamboat Springs's first Olympian was John Steele at Lake Placid, New York, in 1932. Olympians in the photograph above include, from left to right, (first row) Jack Miller, Todd Wilson, David Jarrett, James "Moose" Barrows, Loris Werner, Ted Farwell, Tom Steitz, Ray Heid, Tim Tetreault, and Marvin Crawford; (second row) William "Billy" Kidd, Ann Battele, Nelson Carmichael, Todd Lodwick, Gary Crawford, Gladys "Skeeter" Werner Walker, Jorge Torella, Kris "Fuzz" Feddersen, and Gordon Wren. Below are two additional Olympians, Keith (left) and Paul Wegeman, around 1944 when they came to Steamboat from Denver. Their father, Al Wegeman, trained them both (and other Steamboat skiers) for the Olympics. (Both Tread of Pioneers Museum, Steamboat Springs, Colorado.)

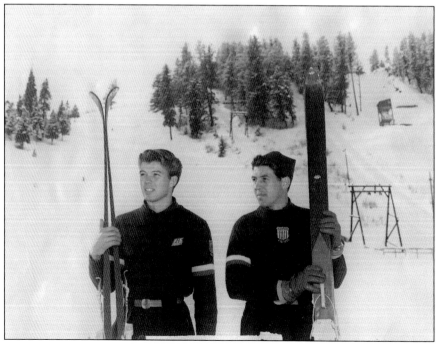

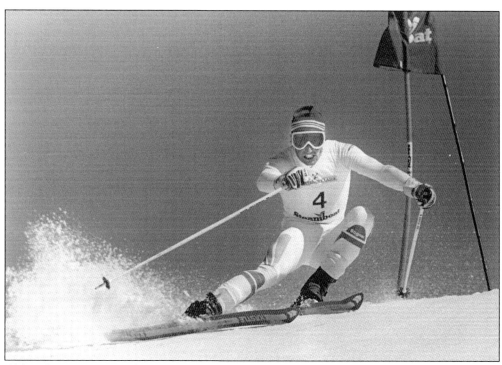

Although Winter Carnival is important to Steamboat, of equal or greater importance is participation in local, national, and international competition. Most important of all is the joy of skiing deep powder on a big mountain with cares and worries far below. These two photographs, both taken in 1987, illustrate the superb skiing available on Howelsen Hill, Mount Werner, and the numerous cross-country trails. (Both Tread of Pioneers Museum, Steamboat Springs, Colorado.)

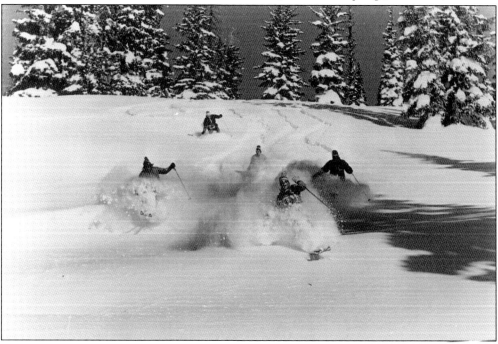

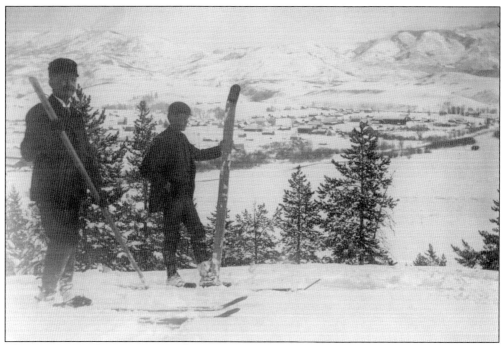

The two men on the mountain south of town about 1915, seen above, appear to be Carl Howelsen (left) and an unidentified companion. Note Howelsen's single ski pole and the city of Steamboat Springs in the background. About 40 years later, the scene was duplicated with more modern equipment, a larger town, many more trees among the buildings, and the same winter snow. (Both Routt National Forest.)

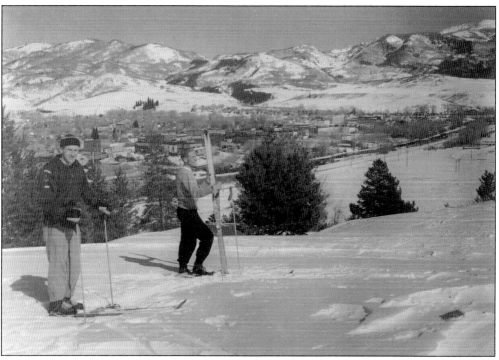

Two

From Rabbit Ears to Bear Ears

Known today as Ute, they call themselves Nuche, people of the mountain tops. For hundreds of years, they roamed the mountains and valleys from the Great Basin to the Great Plains, from the Great Divide Basin to the River San Juan. The Hopi and Navajo called them enemy, but to the white invaders, they were mostly friendly and seldom resorted to violence as their lands filled with miners and settlers. Their greatest chief, Ouray, put it this way, "Take the gold but leave us the land." The Yampatika (sometimes spelled Yamparika) made summer camps all through the upper Yampa. They came to Steamboat Springs, know to the Utes as "medicine water," every spring to hunt, fish, and harvest edible plants.

The first foreign visitors to the valleys of the Elk and Yampa Rivers were trappers pursuing beaver. Next came exploring and hunting parties, and then prospectors scouring the region in search of gold and silver. Few clashes with Utes occurred until Nathan Meeker was made Indian agent at White River, 60 miles southwest of Steamboat. In 1879, he insisted that the Utes quickly become farmers. The Ute men preferred hunting and racing horses. Not satisfied with their slow progress, Meeker ordered the horse racetrack plowed. This led to an uprising now known as the Meeker Massacre.

In the ensuing days, settlers either fled or grouped together for safety as vast forest fires burned in the mountains. The huge burn zones on Storm Mountain, on Sand Mountain, and along the White River are scars from the 1879–1881 period before the Utes were escorted across the Green River to join their kin on the south slopes of the Uinta Mountains.

With the departure of the Ute came the era of the cattle baron; sheep men were mostly forced to stay in Wyoming. Later homesteaders and small ranchers fenced the water holes used by the cattle barons, and the Forest Service was organized to control logging and overgrazing. Open range cattle operations were then doomed. The region today is dotted with hay farms and small ranching operations (sheep and cow), and coal mining and tourism are the most conspicuous industries.

Because the Yampa River is sometimes called Bear River, many believe *yampa* is Ute for bear. However, yampa is the Ute word for a member of the parsley family known for its carrot-flavored tuber, the size of a child's little finger. Easily exhumed with a sharp stick, it was a staple for the Yampatika (yampa eater) Utes and local bears. (Photograph by David Ellis.)

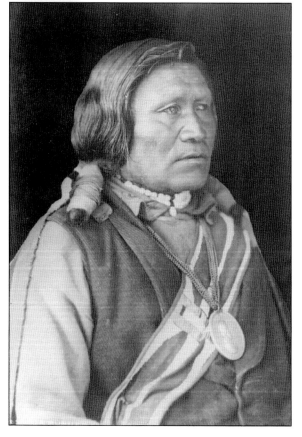

When the first settlers, the Crawford family, arrived in 1875, Yarmonite (Yamanatz or Yamapi) was the local leader of the Yampatika. He was always friendly with the settlers and made bows for his son and Logan Crawford. The two enjoyed hunting chipmunks and, like all boys, just shooting arrows in the air. Before the Meeker incident, Yarmonite warned the Crawfords that trouble was brewing. (Colorado Historical Society.)

The Lewis and Clark Expedition (1803–1806) opened the west to mountain men and trappers. Strangely, the brief fad among American and European gentlemen of wearing a clipped beaver hide on their heads fueled the exploration of the Rocky Mountain West. Here is a wood engraving of a deer hunter's Swedish-style cabin in the Rocky Mountains. (Engraving by Charles Graham, *Harper's Weekly*, April 19, 1890.)

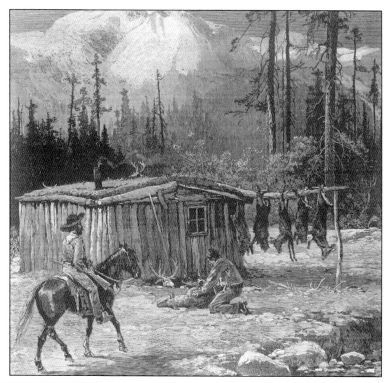

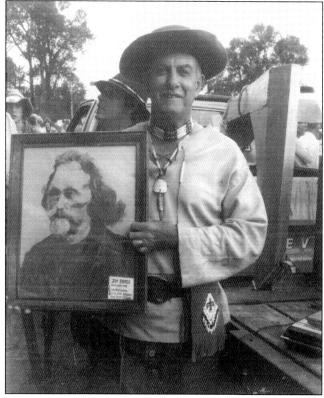

Pictured here is Leighton Baker, author of *Jim Baker the Red-headed Shoshoni*, holding his famous ancestor's likeness. The tag reads "Jim Baker, Mountain man, contemporary with Jim Bridger and Kit Carson." Bakers Peak (elevation 9,445 feet, 50 miles northwest of Steamboat) is named for Jim Baker. He headquartered along the Little Snake River but sometimes prospected for gold near Steamboat. (Museum of Northwest Colorado.)

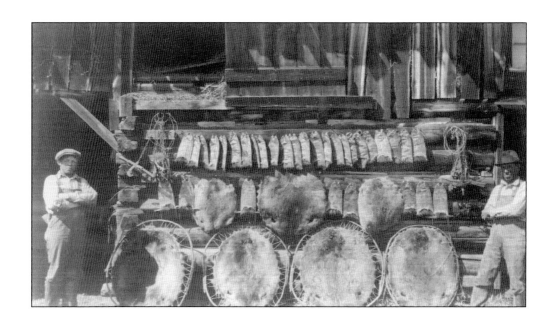

These photographs illustrate the abundance of the animals that the mountain men sought. Clark LaFon from Yampa (probably one of the men) trapped all the pelts pictured above about 1920. The pelts above include muskrats and beaver (laced onto the round wooden hoops). Below, LaFon has muskrats (upper row), three mink, and six coyotes. In the early 20th century, beaver, which were protected in Colorado, would be sold in Utah. (Both Hildred Fogg.)

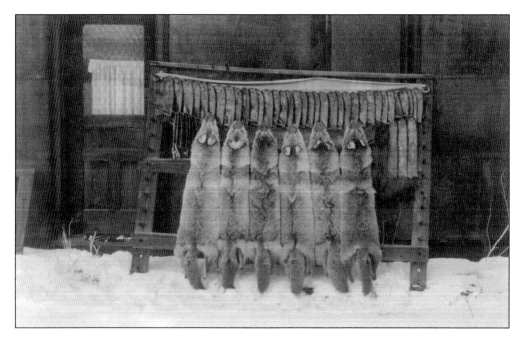

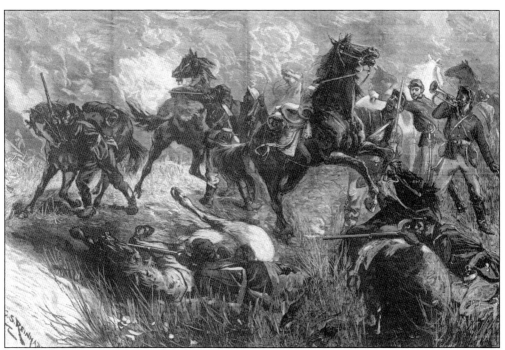

In 1879, Indian agent Nathan Meeker and 11 other non-Native Americans were massacred near Meeker, and Maj. Thomas Thornburgh and 13 soldiers of the relief column were killed in an ambush at Milk River. (The engraving above, from *Harper's Weekly* on November 1, 1879, shows black soldiers among the rescue column.) Huge forest fires, set by the Utes, blackened mountains east, north, and southwest of Steamboat. Three weeks later, the women and children from Meeker were released. These events so angered Coloradoans that in 1881 all of the northern Utes were forced across the Green River to join the Uintah Utes in Utah. In 1887, Colorow (right), a disgruntled chief, led a large hunting party into Colorado but was forced to return to Utah. Through the years, other bands came, the last one in 1914. (Above, C. S. Reinhart; at right, Museum of Northwest Colorado.)

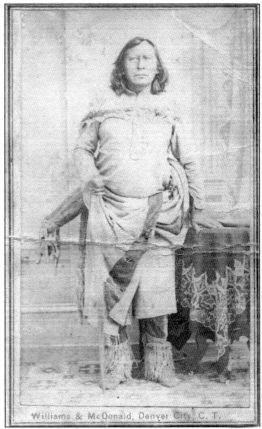

Williams & McDonald, Denver City, C. T.

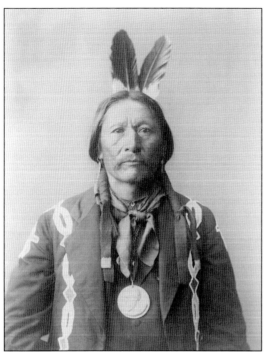

Buckskin Charlie (left), a northern Ute chief, said of reservation life, "I had been a brave man. I had fought the enemies of my tribe by day and by night; I had something to think about all the time, and got the full enjoyment out of the busy and active days as they passed. But now I had nothing to do but eat and sleep and be lazy like a child. The dullness of my life took away all the pleasure of living. I will not be sorry when my time comes to die." (Library of Congress.)

Jim Bridger, famous frontiersman, pioneered the range cattle business. He traded one fat ox for several emaciated oxen newly arrived on the Oregon Trail. After fattening these, he traded for new arrivals, ad infinitum. Ironically Cherokees were the first (1849) to overwinter stock on the lush winter ranges of northwestern Colorado. Displeased with the prairies of Oklahoma, they wintered their herd in Brown's Park en route to the gold fields of California. This drawing appeared in *Harper's Weekly* on October 19, 1867.

Jim Bridger (right) also helped Sir George Gore, a wealthy Irishman, organize what was intended to be the greatest hunting expedition anywhere. Gore's caravan, consisting of 30 wagons, over 110 horses, and sometimes more than 800 people, opened a road from Middle Park over today's Gore Pass into Yampa country. This primitive Gore Pass road was used 20 years later by settlers on their way to Steamboat. Over 3,000 bison and elk, 40 grizzly bears, and a myriad of lesser beasts were slaughtered on the 1854–1856 expedition. The entourage, however, was confronted by Utes who claimed the wild game along the Yampa belonged to them. The Utes were photographed (below) in Colorado Springs in 1913. (At right, Ellis collection; below, Library of Congress.)

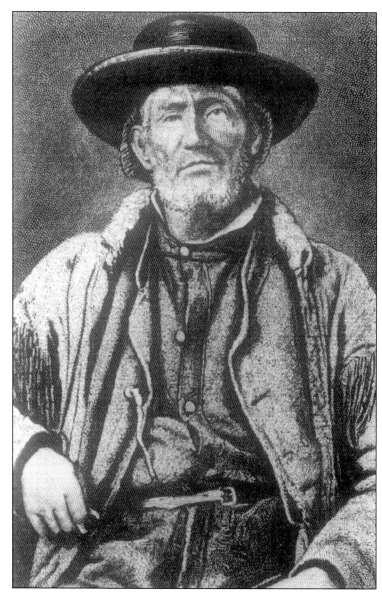

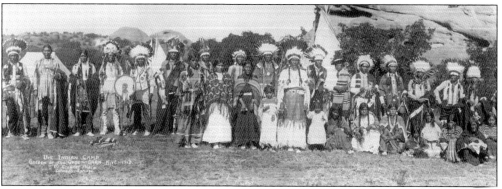

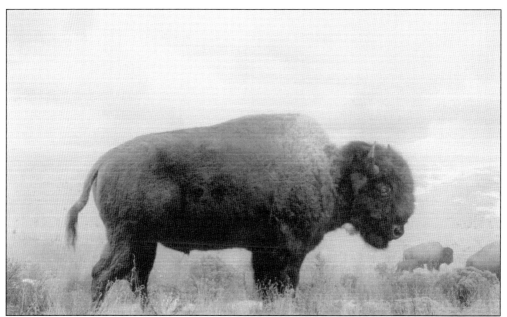

Bison once numbered over 100 million on the Great Plains, and each mountain valley also had its herd. A small number persisted in Egeria Park into the 20th century, and John Rolfe Burroughs saw three bison cows and their hybrid calves (catalo) mixed with cattle at the edge of town about 1910. Even today, bison bones are occasionally found eroding out of riverbanks along the Yampa. (Denver Museum of Nature and Science.)

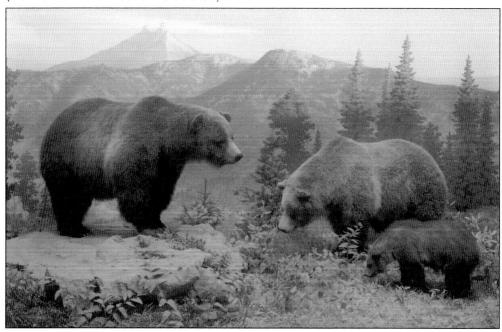

It was once possible to see several black bears at one time along the upper Yampa River. Grizzlies, named for gray-flecked (*gris* in French) pelage, were much less common and stayed more to the high country. The grizzly was long believed to be extirpated from Colorado, but the adult female in this diorama was killed in southwestern Colorado in 1979. (Denver Museum of Nature and Science.)

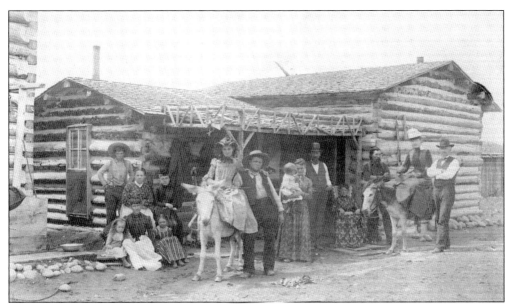

Ora Haley and his ilk presided over domains as large as Rhode Island with cowboys by the score and cattle by the thousands. At rifle point, sheep men were kept at bay, and mace and blades silenced the bleating of hundreds of woolies. Homesteaders, such as the Perry Burgess family here at Steamboat, changed everything with their fences. (Tread of Pioneers Museum, Steamboat Springs, Colorado.)

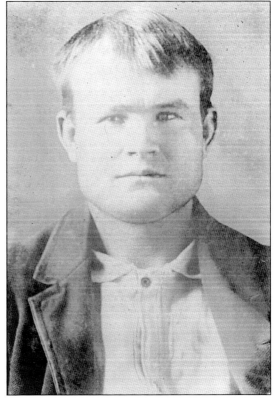

Butch Cassidy (alias George LeRoy Parker), notorious bank and train robber and leader of the Wild Bunch, operated from hideouts in Brown's Hole and the Powder Springs country on the Colorado/Wyoming border. It was at Steamboat, or more accurately across the river at Shorty Anderson's saloon, that Cassidy and his gang debated enlisting to fight in the Spanish-American War or remaining wild. Drink and the sylvan life prevailed. (Library of Congress.)

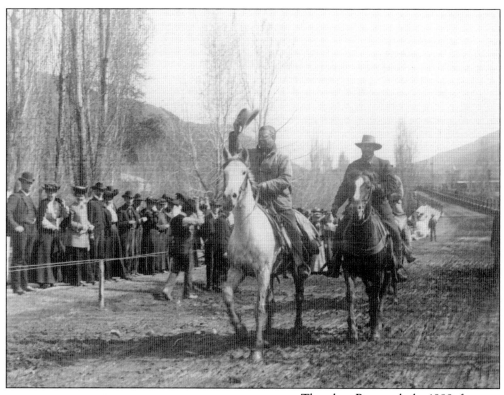

Theodore Roosevelt, by 1888, foresaw that open-range grazing would not persist into the 20th century. To him, the big outfits "with their barbarous, picturesque, and curiously fascinating surroundings, mark a primitive stage of existence as surely as do the great tracts of primeval forest, and like the latter, must pass away before the onward march of our people." The kingdom of Ora Haley was snipped apart piece by piece as fences favored the homesteader and the small rancher, and the U.S. Forest Service favored sheep where once only cattle grazed. Roosevelt's early hunts in Colorado gave him firsthand knowledge of the area, and on June 12, 1905, he created the Park Range Forest Reserve. Roosevelt is pictured above riding into Glenwood Springs in 1903 after a hunt. At left is early Yampa District ranger Charles "Pop" Euler around 1912. (Above, Library of Congress; at left, Hayden Heritage Center.)

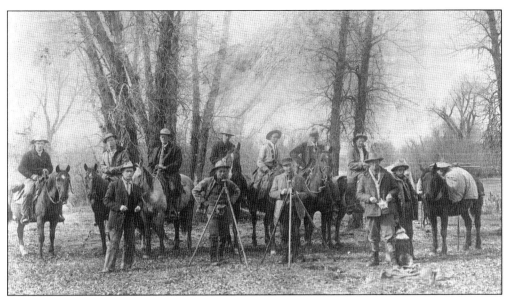

Early settlers begrudged the loss of their supposed rights to graze cattle, cut timber, and kill game when and where they wished. Even Harry Ratliff, ardent guardian of Routt National Forest, was accosted for cutting timber illegally immediately before being hired as forest ranger. Ratliff diligently counted cattle, proving that the cattle barons sometimes had twice as many cattle in the forest as their permits allowed. For his trouble, the cattle barons had him tried as a horse thief. Acquitted, he continued to implement conservation policies. Pictured above is a Forest Service ranger's exam (i.e. cattle count) on the Routt National Forest. From left to right are Oliver Taylor, Fred Cates, Angus Taylor, unidentified, Austin P. Russell, unidentified, Ray Peck, unidentified, Fred Foster, unidentified, L. L. "Lew" Segur, and Harry Ratliff. Below, Ranger Frank Rose feeds an orphaned bear cub in the 1930s. (Both Hayden Heritage Center.)

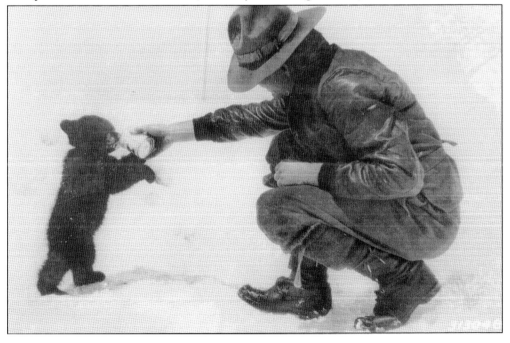

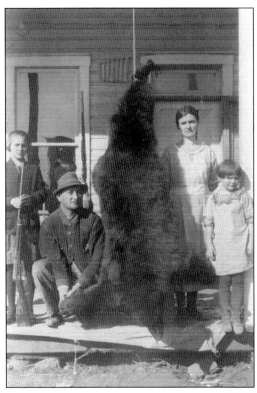

Scott Teague (at left, kneeling) was described by Howard Rockhill of Yampa as "a stocky man of medium height." Born in Texas in 1863, Teague lived in the Ozarks and then drifted into Colorado before 1900. Rockhill said Teague was "primarily a 'Dude Wrangler' during the season. After that, trapper-hunter and very little farming [and] whenever stockmen from Colorado . . . had 'varmint' trouble, they called Scott. He took out with his buckboard loaded with camping equipment, followed by his hounds." In 1918, Teague was on Storm Mountain tracking a bear that was accused of killing cattle. Below, his hounds have treed a bear. Teague once caught two black bear cubs and shot two adults in one day. One of Teague's famous hunting clients was Zane Gray. (Both Hildred Fogg.)

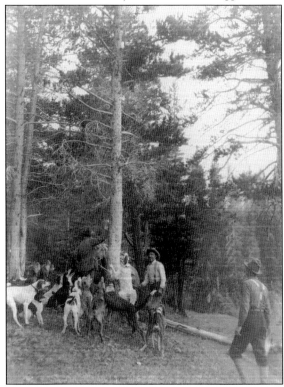

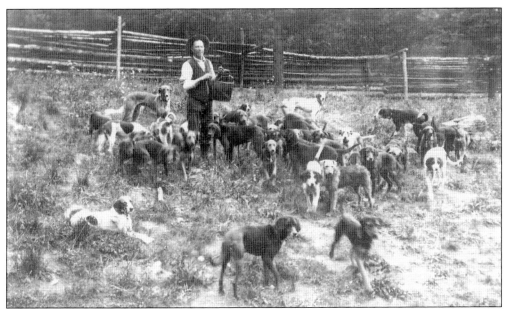

This photograph shows Teague with his hounds. Rockhill wrote, "I have seen [Teague] leave town taking out on a cat hunt, followed by 20 or 30 dogs chained together two by two. Each veteran hound was chained to an apprentice pup." Teague used a "silver mounted cow horn" to control his dogs, and "when he blew a blast on that horn, the dogs took notice." (Hildred Fogg.)

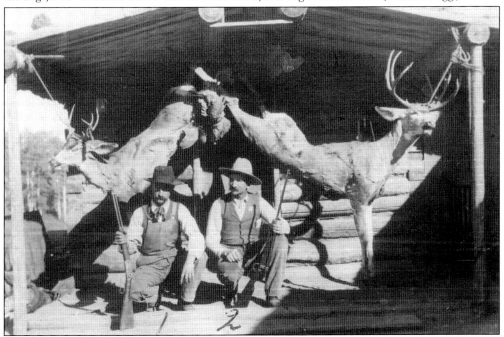

Pictured here are Lem Lindsey (left) and Harvey Smith, residents of Oak Creek originally from Missouri, with the results of a hunting trip. Game in the mountains around Steamboat was plentiful and was taken for domestic use without permit or government complaint by early settlers. However, the deer and grouse in this photograph are presumably legal inasmuch as Smith is wearing a badge. (Hildred Fogg.)

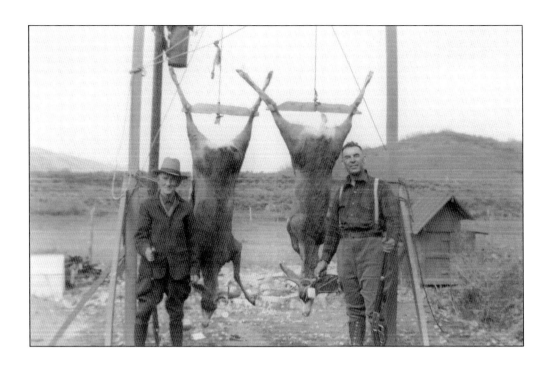

A trapper known only as Kelly was among the first white men to visit the Yampa Valley. For him, the days of good hunting were over by 1839 when he guided Thomas J. Farnham and his Peoria Dragoons through the valley on their way to California. Decades later, however, the profusion of game was still a big draw for visitors and settlers. Pictured above are Frank Light (left) and his son Clarence with deer they shot in the 1920s. Below, from left to right are F. M. Light's grandchildren Frank, Kneeland, and Audrey with two elk shot in 1928. Annabeth Lockhart wrote that the wild meat was especially appreciated during the Depression. (Both F. M. Light & Sons.)

Deer and elk were so plentiful in the 1870s that wild game was sold to mining camps, and thousands of pounds of jerky from North Park and Meeker went to Cheyenne and Denver. By 1900, the herds were severely depleted. This deer was shot in 1881 by James Crawford and is on display at the Tread of Pioneers Museum. (Tread of Pioneers Museum, Steamboat Springs, Colorado.)

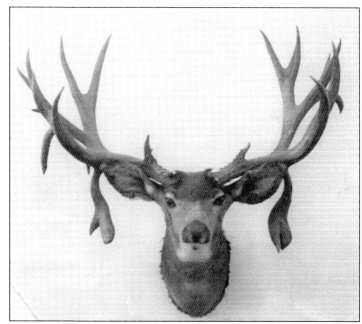

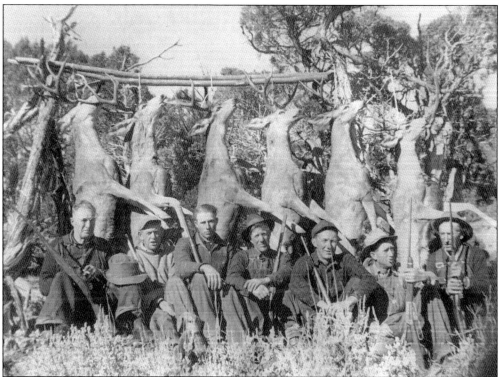

Mule deer once migrated in great numbers to the lower sagebrush-juniper regions to winter. With improved transportation, Routt County residents were able to follow remnant herds. Pictured from left to right are Howard Allen, Clyde Page, Buford Huffstetler, Pete Degrouts, Otto Gumprecht, Arden Huffstetler, and George Gumprecht after their successful buck hunt at Irish Canyon (north of Maybell) in 1944. (Hildred Fogg.)

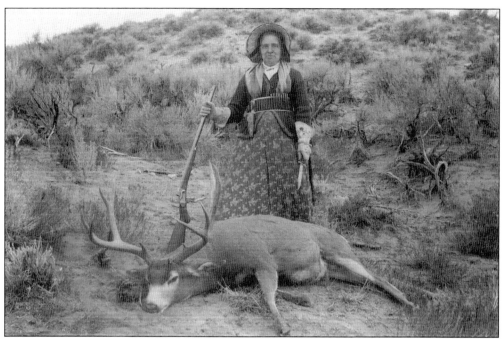

The story of big-game hunting along the Yampa would be incomplete without mention of Mary Augusta Wallihan, seen above. Fortunately "Gusty" wrote as well as she shot, and her husband could use a camera. Together they published many accounts of their hunts, including an 1891 incident when she dropped two big mule deer with one shot. She wrote, "I confess I was a little selfish—I wanted both bucks very much. As I had lost the large one [earlier] I thought two with one shot would please my husband very much." Below, Gusty's husband, Allen "A. G." Wallihan, documented a hunting party near Hahn's Peak about 1900. (Above, Tread of Pioneers Museum, Steamboat Springs, Colorado; below, Zelma Nash.)

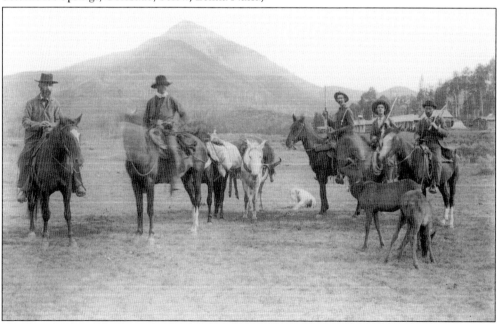

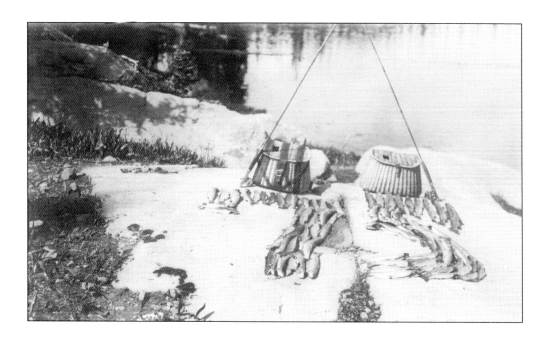

Fish added protein to the diet of early settlers. Clarence Light sometimes caught 80 fish in a day and thought a 50-fish day was poor fishing. Here he has arranged 75 fish to illustrate the number caught. No license was necessary at first, then both license and limits were imposed. When the limit was 20 fish, Clarence Light said, "In a family such as ours with seven children and two adults, nine people to feed, 20 fish just made one meal and I thought we should catch more, but it soon got to the point a fisherman was lucky if he could catch 20 fish." Below, Ina Huffman, daughter of Ora and Mary Perry of Toponas, poses with 34 fish cleaned and ready to cook. (Above, F. M. Light & Sons; below, Hildred Fogg.)

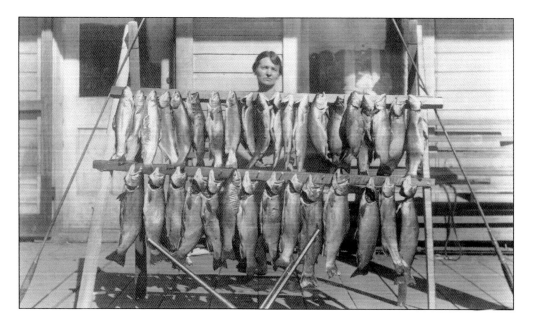

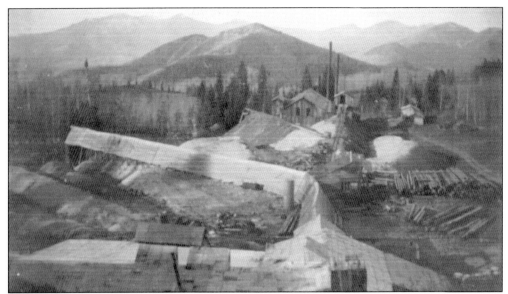

Gold mines begin with prospectors panning the streambeds, then working upstream until the lode is located. Drifts and shafts were then used to extract larger quantities. Joseph Hahn first came to the mountain that was to bear his name in 1860; he returned in 1865 with William Doyle and George Way. Doyle reported, "We found gold on every side of the peak, but not in sufficient quantities to pay for work with the pan." The next summer, they led about 50 prospectors to Hahn's Peak. Hahn, however, died the following winter when he and Doyle tried to flee starvation in the high country. In 1874, the Hahn's Peak Mining District was formed. Both of these photographs (the image below was taken in 1926) are of the Royal Flush Mine at Hahn's Peak. (Above, Zelma Nash; below, Tread of Pioneers Museum, Steamboat Springs, Colorado.)

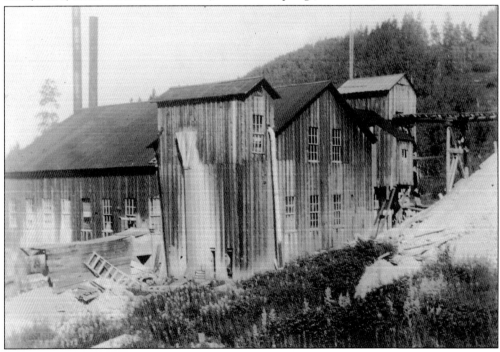

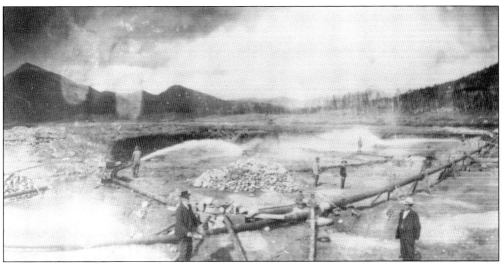

In 1875, John Farwell purchased many Hahn's Peak claims and built a town, a wagon road to ship in a sawmill, and a 15-mile ditch to bring water for hydraulic sluicing. When Farwell put several thousand yards of gravel through the sluice boxes and found no gold, he sold out. The new owner, Robert McIntosh, then moved the operation and in two months found gold worth $30,000. It is estimated that through the years $500,000 to $600,000 worth of gold has been found at Hahn's Peak. The peak is riddled with tunnels from people looking for the elusive lode. Later merchants in Steamboat catered to the mining camps at Hahn's Peak, including a daily stage (below). Don Whipple and Milby Frazier operated the stage around 1900. By 1910, both Whipple and Frazier listed themselves as farmers. (Above, Routt National Forest; below, Zelma Nash.)

ALL ABOARD FOR
HAHN'S PEAK,
COLUMBINE,
WHISKY PARK AND
GRAND ENCAMPMENT
Gold and Silver Mining Camps.

Stages leave Steamboat Springs Daily.

WHIPPLE & FRAZIER, Props

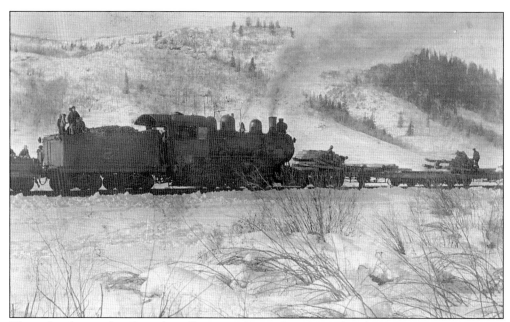

The railroad arrived in Steamboat Springs in December 1908. The plan was to connect Denver with Salt Lake City, but tracks were never laid past Craig. Nevertheless, the railroad connected Steamboat with the outside world. Cattle and coal were shipped out, and passengers arrived. From 1909 to 1913, Steamboat shipped more cattle to big cities in the East than any other town in the West. (Hayden Heritage Center.)

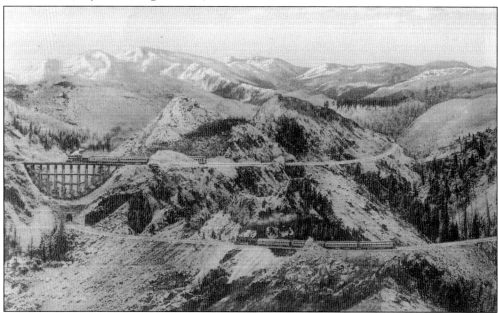

Prior to completion of the Moffat Tunnel in 1928, the largest operating expense for the Denver and Salt Lake Railroad (Moffat Road) was getting trains across the Continental Divide. The railway had grades up to 4 percent, and the train crews battled winter snow. This 1910 illustration is claimed to be "from actual photographs of the most prominent views on the Denver and Salt Lake Railroad—Moffat Road" and is from the book, *Over the Rockies to the Top of the World.*

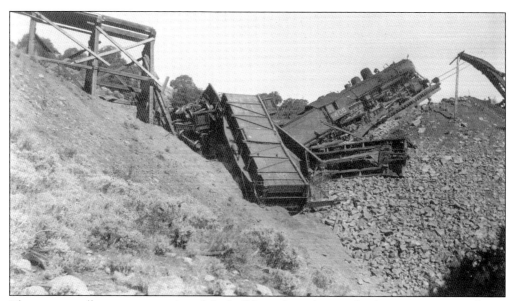

The many small canyons necessitated the building of wooden trestles, but some were simply not adequate. This Egeria Park train wreck in 1926 occurred at the crossing of Rock Creek Canyon. (Hildred Fogg.)

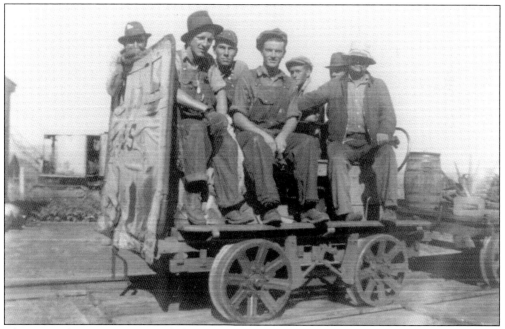

These men from Yampa are ready for a day's work on the railroad in 1930. The section foreman, William Manos, is at far right; the others are unidentified. The tool car (right) also carried all the materials needed to maintain the tracks. The men worked from 8:00 a.m. to 5:00 p.m. six days a week, no matter the weather. In winter, lunch often had to be thawed over a bonfire. (Hildred Fogg.)

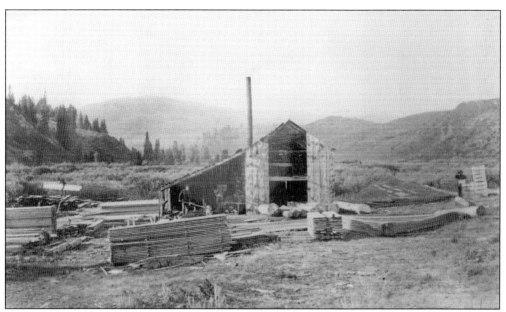

A sawmill changes a log village into a frame town. Horace Suttle's mill, seen here, supplied boards for Steamboat, while his diminutive wife, Icibinda, traveled the countryside bundled up on a toboggan behind snowshoe or ski to serve as midwife or to substitute for a medical doctor. (Tread of Pioneers Museum, Steamboat Springs, Colorado.)

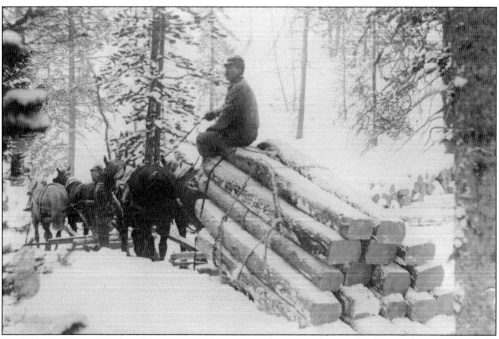

By 1913, the Sarvis Timber Company was harvesting logs 17 miles south of Steamboat. During the fall and winter months, men cut logs, peeled off the bark, and stacked them at the head of Sarvis Creek. In 1916, the company advertised that it intended to install an aerial tram, replacing the sleds and teams, and thereby making it possible to log during the summer. (Routt National Forest.)

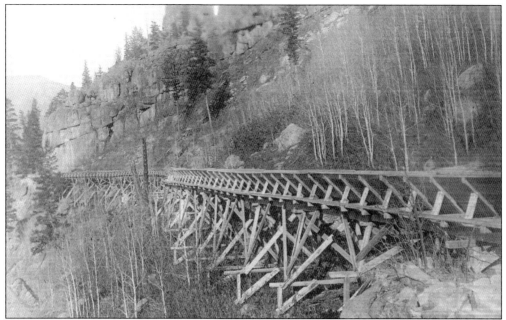

The Sarvis Timber Company built this 7-mile flume to send logs down the mountain to the Yampa River, after which the logs were floated to the mill at Steamboat. (The photograph above was taken in 1913.) Timber from the mountains was not only used to construct local buildings, but in 1916, it went by rail as far east as Omaha, Nebraska. Also, untold numbers of railroad ties and telegraph poles were cut, many from the Hahn's Peak area. These were floated north to Fort Steele, Wyoming. By 1905, Steamboat also had a brick manufacturer. F. M. Light purchased bricks for his store from the Trogler Brick Company. (Above, Hayden Heritage Center; below, Routt National Forest.)

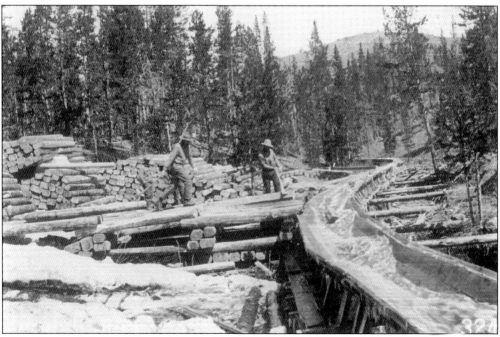

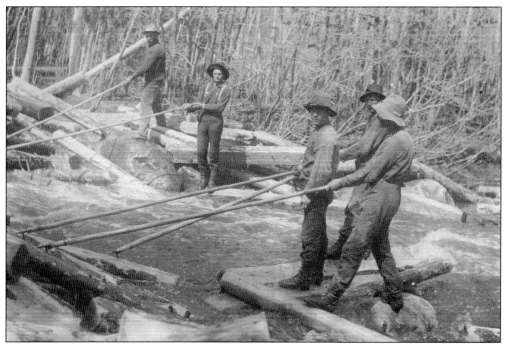

In 1916, the big log drive began on Monday, May 1, and was expected to last 20–25 days. As reported in the *Routt County Sentinel*, most of the "river rats" using cant hooks (above) were "skilled and seasoned in the ways of the river, having in most cases come from the logging woods of Michigan and Wisconsin." Sarvis Timber employed 25 men to break up log jams and keep the waterway clear; a log jam could take out the strongest and most stable bridge. When the logs reached Steamboat, they were held in a pond. The logs from this run were expected to produce 4 million board feet of lumber, the milling and finishing of which would take all summer. (Above, Routt National Forest; below, Museum of Northwest Colorado.)

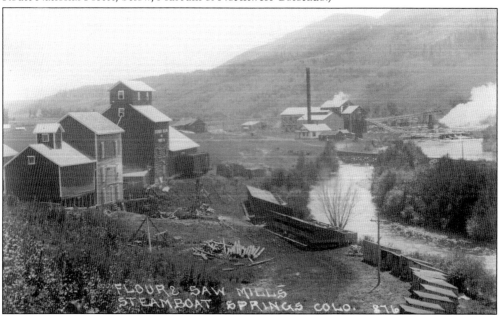

An early grain mill at Steamboat used the river current to turn its gears, grinding both corn and wheat. The mill also sold cottonseed cake and flaxseed meal to feed animals. Then in 1921, new machinery was installed, making it possible to grind 75 barrels of flour each day. The intent was to process grains grown in Routt and Moffat Counties. The Yampa Valley Mill and Elevator Company provided Routt County residents with Yampa Valley Best (first-grade flour, sack pictured at right) and Steamboat Special (second-grade flour). A spectacular fire in February 1958 (below) destroyed both the mill and the grain elevator. (At right, photograph by David Ellis, Museum of Northwest Colorado; below, Tread of Pioneers Museum, Steamboat Springs, Colorado.)

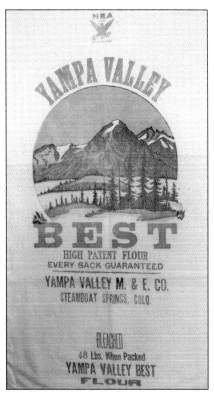

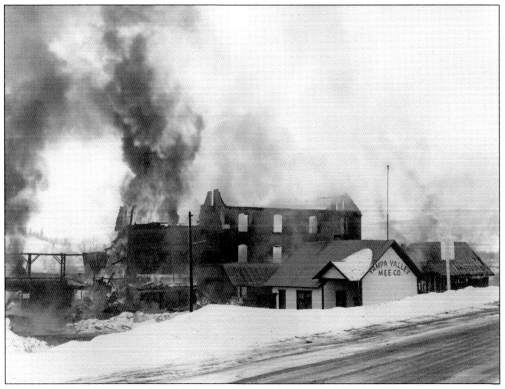

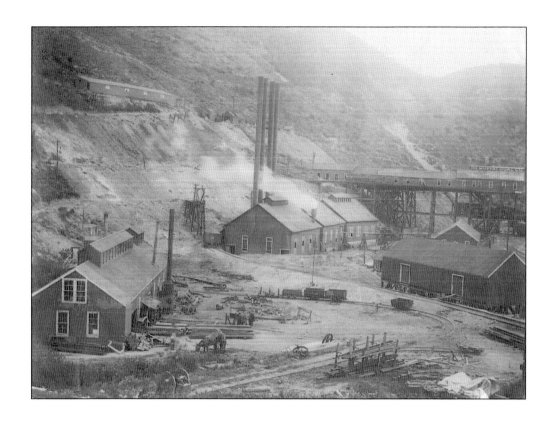

Coal, discovered shortly after settlement in Routt County, was originally mined only for local use. In 1906, the U.S. Geological Survey surveyed the Yampa Valley coalfields and found extensive deposits, but surveyor William Weston noted, "Without a railroad, no shipments of hay, grain, vegetables, or fruit can be made any more than can the coals." David Moffat changed this by providing capital for railroad construction. When the railroad reached Oak Creek, coal could finally be shipped east. The Moffat Coal Company (above) and Yampa Valley Coal (below) were but two of the many mines in the area. John Wolfersperger was engineer and superintendent for these two companies in 1913–1915. The Moffat Mine was owned by Samuel Perry, father of Charlotte and Marjorie Perry, early contributors to Steamboat's economy. (Above, Historical Society of Oak Creek and Phippsburg; below, Library of Congress.)

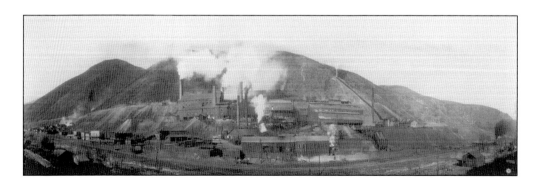

The Haybro (a contraction of Hayden Brothers) tipple, where coal was loaded on trains bound for Denver, was "The Cream of Routt County." The first mine supplying this tipple (1913) was on the ridge above, but the coal was of poor quality, so operations closed in 1924. Thereafter, a mine shaft was opened hundreds of feet beneath the hill, the only shaft mine in southern Routt County. (Hildred Fogg.)

The once-substantial town of Mount Harris came into being in 1914 and disappeared after 1958. During this interval, the Colorado-Utah Coal Company operated an underground mine just south of the Yampa River with a conveyor system delivering coal to a tipple on the railroad. The mine was among the nation's safest with only eight miners killed in 40 years; however, 10 others died transporting the coal. (Hildred Fogg.)

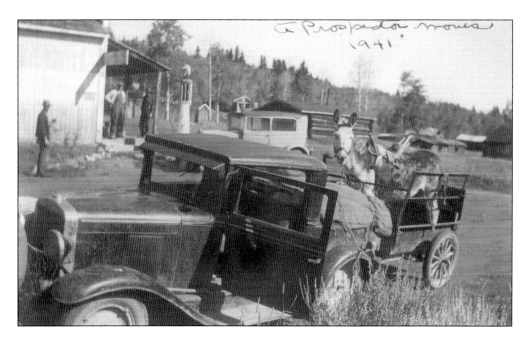

During World War I, gold and silver mining at Hahn's Peak effectively ceased. However, prospectors have continued to look for gold in the streams and on the slopes. Prospectors usually found burros the most efficient way to carry supplies to their claims. A burro could carry 200 pounds if evenly divided into two bags. Above, a prospector's burro is waiting for his owner outside the Columbine store in 1941. Below, Carey Barber is showing an unidentified woman how to pan for gold in 1947 at Columbine. (Above, Janice Kay; below, Museum of Northwest Colorado.)

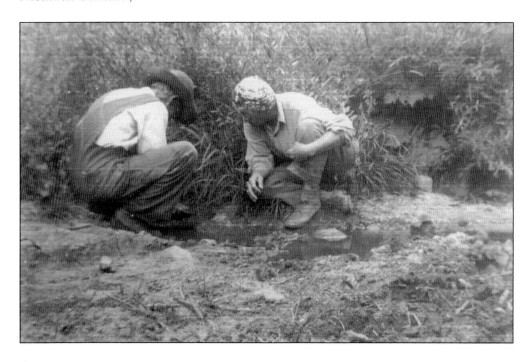

Three

THE PIONEERS FROM CROUCHING LION TO COLUMBINE

"The vast district of Northwestern Colorado . . . has been the slowest part of the state to receive settlers," wrote Fr. William J. Howlett who visited Steamboat in 1880. "Cut off by mountain ranges from railroads and markets, it has been left to herds of cattle and a few venturesome spirits who cared to brave solitude and privation."

James H. Crawford and friends traversed the upper Yampa in 1874. When they were near Hunt Creek (close to today's Phippsburg), a lone prospector told them of a wonderful site with warm springs; one he called Steamboat Spring. Although the springs were far from their route, Crawford and one friend followed the river and found the springs. Enamored of the spot, the pair put up a "notice of location" and the stone foundation for a future house. They returned to winter at Hot Sulphur Springs, but the Crawford family came to settle at Steamboat in 1875.

From an isolated cabin, a village slowly grew. Once the Utes were removed (1879–1881), isolated homes were more secure and settlers scattered across the landscape, from Toponas, meaning "crouching lion" in the Ute language, to Columbine and from Steamboat to Hayden. It is an oft-repeated saga: each village began with a log home. With children, a school was organized. The school met in someone's home until a schoolhouse was built. Same with the tiny congregations that first met in homes before a modest church could be built, then a second. As soon as a town had a score of houses, a bank was organized, a newspaper printed, and mercantile stores opened for business. Of course, commerce came, not only from the town but also from the scattered farmsteads.

With towns came an era of fierce competition for primacy. Eventually Routt County was divided, and Craig became the capital of Moffat County while the county seat of Routt County bounced from Hayden to Hahn's Peak and then to Steamboat. A beautiful courthouse of cream-colored bricks decorated with pulsichrome terra-cotta tile was completed in 1923. Steamboat's ascendancy came from the earlier arrival of the railroad, the greater potential for tourism with the hot springs, the twin rivers, and later because gray clouds dropped their heavy burden on Storm Mountain.

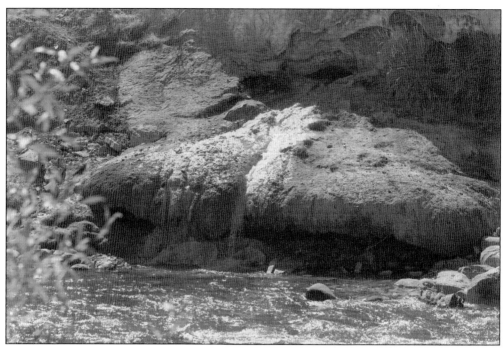

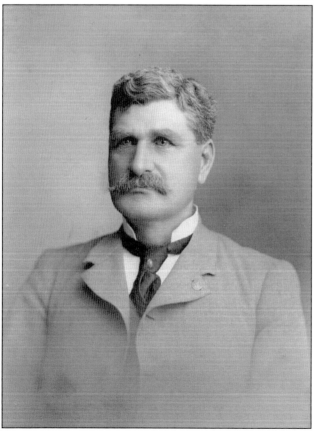

Said Steamboat's founder, James Harvey Crawford (left), "I am not sure that anyone really knows the origin of the name. . . . Naturally, it was due to the intermittent noise emitted by the spouting, puffing gusher . . . [In 1875,] the spring [above] was performing strong, but it is comparatively quiet now and has been ever since the railroad came in. At a distance of two or three hundred yards, it sounded exactly like a steamboat laboring upstream. The story is that a pair of French trappers or prospectors first applied the name. . . . Approaching the location of the spring they heard the noise; one of them turned to the other in astonishment, exclaiming, 'Steamboat, by Gar!' . . . That is the story. It may be pure fiction; I cannot say." (Above, photograph by David Ellis; at left, Tread of Pioneers Museum, Steamboat Springs, Colorado.)

The founding matriarch of Steamboat Springs, Margaret B. Crawford (right) brought culture to a harsh land. She opened her door to travelers and townspeople and established the first church and school. Nevertheless, in the early years, she sometimes complained of winter loneliness, "For months at a time, I have not heard a woman's voice." Such feelings, likely compounded by her husband's departure with the cattle to winter in a warmer clime along the Colorado River near Burns, prompted her to insist Crawford stay home and make his living developing the town. Although the Crawford family began life at Steamboat in a log cabin, in the 1890s they constructed a two-story house (below) of Dakota sandstone from Quarry (now Emerald) Mountain. (At right, Tread of Pioneers Museum, Steamboat Springs, Colorado; below, photograph by Sherri Foster and Cheryl Brunner, 1970, Steamboat Springs High School.)

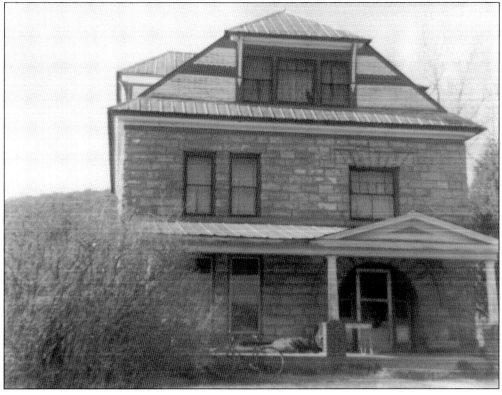

Well populated gold mining camps made Hahn's Peak a reasonable choice for the Routt County seat in 1879, but by the early 20th century, the camps were mostly deserted. Nevertheless, when court met each spring and fall, Steamboat residents traveled to the town. Finally, in 1912, the county seat was moved to Steamboat Springs. This c. 1910 photograph was taken at Hahn's Peak. All of the people are unidentified. (Museum of Northwest Colorado.)

Dr. John Campbell became something of an orator, entertaining residents during cold, deep winters with his lectures on ancient civilizations. He also collected and passed along what he could on the prehistory of the Yampatika Utes. Campbell and his wife, Charlotte, were both originally from Indiana. (Both Museum of Northwest Colorado.)

As president and founder of Milner Bank and Trust Company, F. Emery Milner, pictured here, was probably the most wealthy and influential person in Steamboat. The bank was private until 1906 when it was incorporated. Milner also owned a large ranch 10 miles west of Steamboat where the town of Milner today bears his name. (Tread of Pioneers Museum, Steamboat Springs, Colorado.)

The Milner Bank mostly served large ranch operators; the numerous small ranchers and farmers used First National. Charles S. Merrill was president of First National Bank, secretary of the Bear River Stock Association, and owner of various lumber and ranching enterprises. Pictured here are First National Bank employees in 1921. From left to right are Earl Welch, Dora Pritchett, Hazel Light, A. R. Brown, and Grace Remington. (Tread of Pioneers Museum, Steamboat Springs, Colorado.)

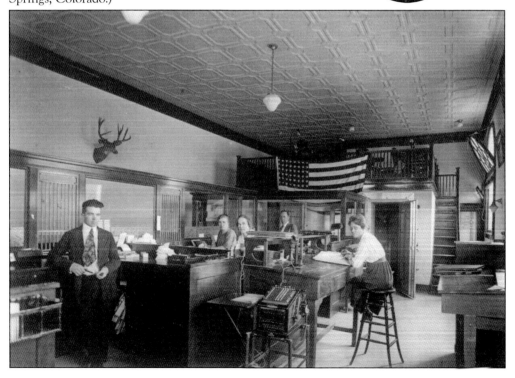

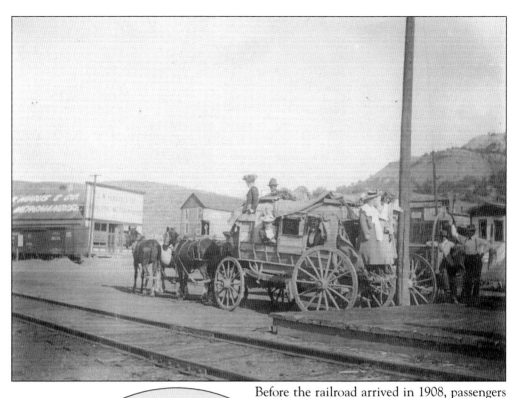

Before the railroad arrived in 1908, passengers came to Steamboat from Wolcott via the stage (pictured above around 1905 departing Wolcott). Note the Hugus store in the background, part of a chain of stores from Rawlins, Wyoming, to Clifton and Grandby. As the *Yampa Leader* reported in July 1914, on the occasion of Samuel C. Reid's 69th birthday, "Those who have come here [Routt County] since the advent of the railroad can hardly understand what an overland trip ment [*sic*] in an early day or the hardships of early pioneer life." Reid and his wife, Ida (left), homesteaded at Toponas in 1883. The newspaper also reported that "their home on the Egeria was for years one of the favorite stopping place [*sic*] for the freighter and the tourist." (Above, Hayden Heritage Center; at left, Hildred Fogg.)

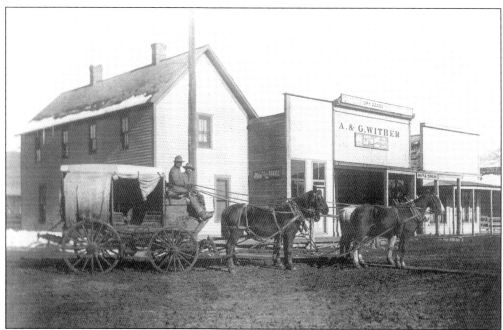

As late as 1903 (for the Burroughs family) or 1905 (when F. M. Light and George C. Merrill arrived), the trip by stage was an adventure. The stage above is in front of the A&G Wither store in Steamboat. John Rolfe Burroughs described glaze ice alternating with quagmire, with the stage either skidding or bogging down. He also reported that it tipped over three times on his first trip, whereupon the passengers had to alight and help set it upright. Clarence Light remembered that they ate elk stew en route and spent the night at the Antlers Hotel in Yampa, seen below. The next day he rode on top with the driver and, not having adequate clothing, was loaned a bearskin coat to keep warm. (Above, Ellis collection; below, Hildred Fogg.)

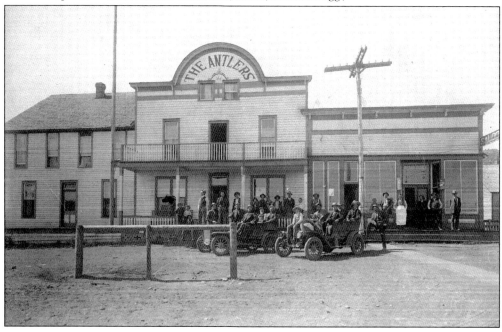

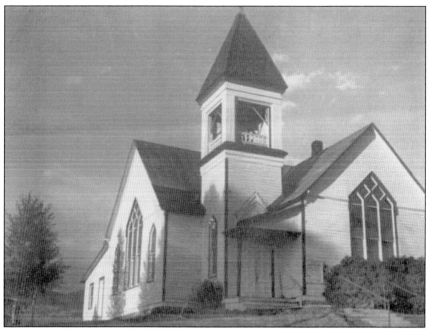

The first religious services in Steamboat were held in the Crawford home in 1876 and were conducted by Methodist minister Dr. Creary. The first church constructed was nondenominational. Margaret Crawford and Ida Monson were instrumental in promoting its construction. In 1889, the Congregationalists organized separately (above) with Rev. J. W. Gunn as pastor. The original Methodist church was built in 1901. John Rolfe Burroughs recounted a "Bible Reading Marathon" one Sunday in 1924 at the Methodist church. It began in Matthew at 4:30 a.m. and ended after 11:00 p.m. in Revelation. Henry Mencken noted the event in the Americana column in his national magazine, *American Mercury*. Steamboat also had a Christian Science church (below). (Above, F. M. Light & Sons; below, Tread of Pioneers Museum, Steamboat Springs, Colorado.)

Fr. John James Meyers, at right, was known as the "Mountain Priest" and, beginning about 1919, lived with the F. M. Light family. As noted in Meyers's 1938 obituary, "He was never too tired or too sick to travel out in all kinds of weather to administer to his followers and risked danger after danger to visit some dying parishioner, to baptize a new-born baby, or give comfort to some saddened wife or mother." In 2007, Fr. Ernest Bayer dressed as the Mountain Priest for a parade to pay homage to the many miles Father Meyers traveled: he held mass in Steamboat, Fraser, Kremmling, and Oak Creek. All of the F. M. Light family except son Clarence became Catholic. Helen Light, wife of son Wayne, was instrumental in preserving the early history of Holy Name Parish. Pictured below are, from left to right, F. M.'s daughters Hazel, Audrey, and Marie in 1916. (Both F. M. Light & Sons.)

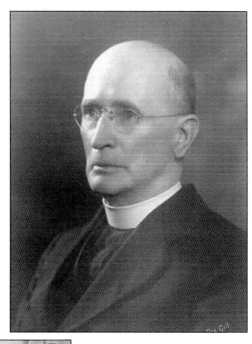

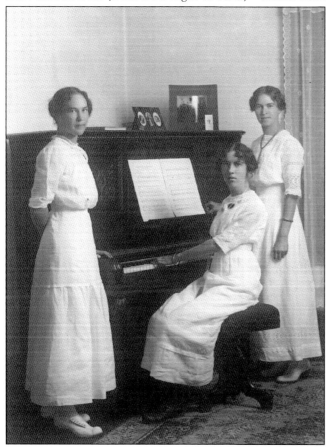

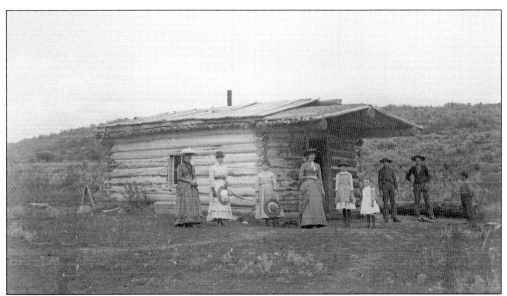

School classes were first held in the Crawford home before this log schoolhouse was built in 1884. It is pictured above around 1890. The people are, from left to right, Cushie Suttle, Ida Woolery, May Keller, Lulie Crawford (teacher), Maude Keller, Mary Crawford, John Crawford, John Sampson, and Oscar Woolery. Later a two-story frame school was built on Pine Street, but that structure burned on December 8, 1910. The citizens of Steamboat replaced the second school with a three-story brick and stone building, seen below, which was dedicated in November 1911. The high school teachers included J. M. Childress, Anna Shearer, Kathryn Dowling, and Florence Baker. The grammar school teachers were Florence Baker, Julia Johnston, Irene Rogers, Harriet Chase, Pearl Gardner, Letitia Scott, and Margaret Miller. (Above, Museum of Northwest Colorado; below, Annabeth Lockhart.)

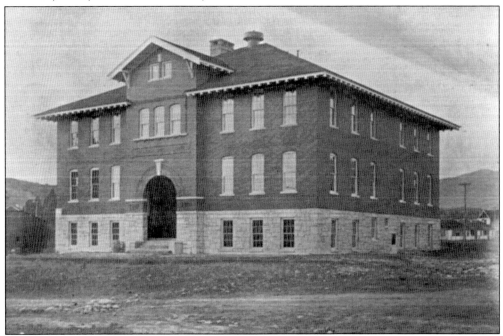

Anna Shearer (below) was educated in Denver and came to Steamboat Springs in 1911 to teach Latin and German at the high school. She became principal of the school and taught until 1915 when she married Clarence Light, one of the owners of F. M. Light & Sons, a centennial mercantile institution in western Colorado. A few years earlier, Nettie Lufkin (right) also came to Routt County and taught grammar school. She lived at Sidney (a hamlet about seven miles south of Steamboat) and married Earnest Arnold. These women are just two of many who have helped educate the children of Routt County. (At right, Tread of Pioneers Museum, Steamboat Springs, Colorado; below, Annabeth Lockhart.)

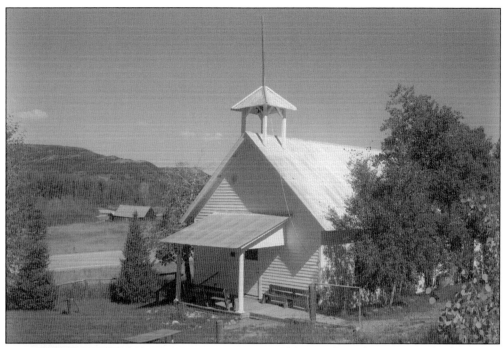

Steamboat Springs had separate elementary and secondary school classes. Remote locations, however, had small, one- or two-room schools (with many grades combined) until nearly 1960. The Moon Hill School District was established in 1887; its school (above) was built in 1913 and is one of the earliest frame schools in Routt County. Today it is used as a community center. At left are the children of the lower grades at Clark c. 1927. From left to right are ? Smith, Ray Whitmer, Leland Dixon, Avis Dixon, Robert Howard, Wilma Howard, Russell Whitmer, and Mary Whitmer. (Above, photograph by David Ellis; at left, Clark Post Office.)

Historian Jim Stanko (and briefly David Ellis) attended the Southside School, built in 1913 and still standing (shown at right), until closure in 1958. Also on the school grounds were a tiny teacherage, a boys' outhouse, a girls' outhouse, an outdoor pump, and a small horse barn. As late as 1956, huge maps of World War I hung on the walls. (Tread of Pioneers Museum, Steamboat Springs, Colorado.)

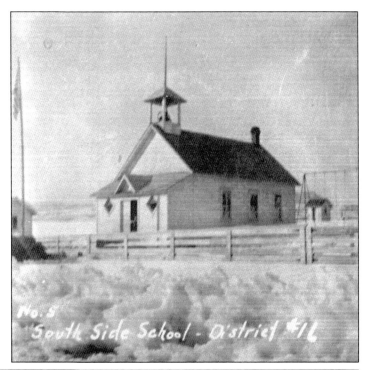

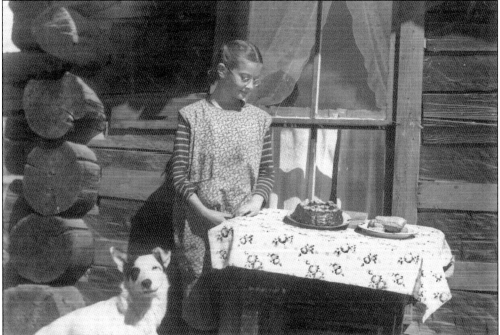

Single children in remote communities, like Janice Juel (above) in Columbine, could choose which school to attend, and the county paid board. In *Historic Hahn's Peak*, author Thelma Stevenson wrote of Janice's mother, "No friendlier soul than Gertrude Juel ever homed at Columbine Gold Camp." The same could be said of her daughter, when grown. This photograph of Janice with her dog, Pickle Paws, shows the first cake she ever baked. (Janice Kay.)

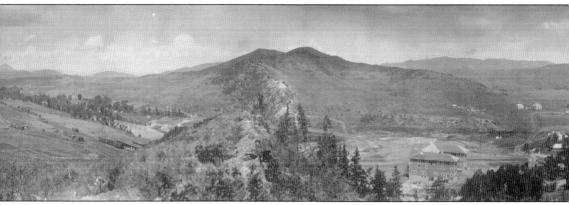

To take an "aerial" photograph of Steamboat Springs, a photographer simply has to walk up a mountain and snap his picture. This photograph was taken in 1909, specifically to show the

In 1885, James Crawford secured the backing of several Boulder businessmen and laid out streets for the Steamboat Springs town site. Additional buildings were constructed, including the Sheridan Hotel, built by Henry Schaffnitt Sr., who had served in the Civil War under Gen. Philip H. Sheridan. The scattered buildings of early Steamboat are seen in this photograph by A. G. Wallihan in 1890. (Musuem of Northwest Colorado.)

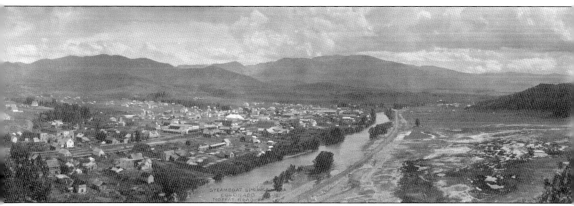

Moffat Road (railroad). Although the panoramic lens distorts the scene slightly, both the Cabin Hotel and the railroad depot can be identified in the left half of the photograph (with part of the mountain between them in the foreground). (Library of Congress.)

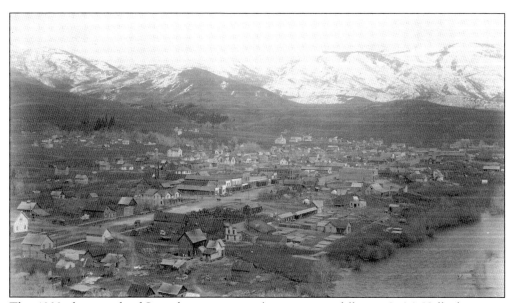

This 1909 photograph of Steamboat appears to be a spring or fall view. L. M. Hellenburst was bicycling around northwest Colorado and stopped to take this picture. In 1966, when Hellenburst was in his 80s, he sent photographs to Chuck Stoddard at the *Empire Courier* hoping that they would be useful in documenting history. (Museum of Northwest Colorado.)

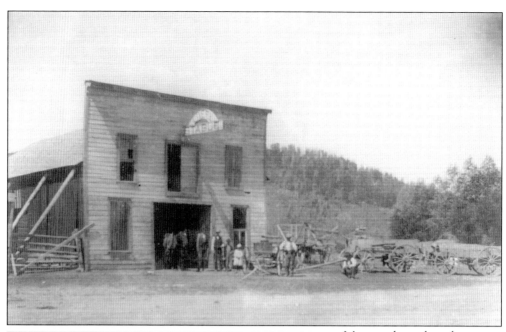

Many early settlers along the Yampa and Elk Rivers eventually moved into Steamboat Springs. The Morgan family, originally from Wales, opened a trading post in 1874 near Craig. In 1879, a few weeks before the Meeker Massacre, they trailed in 1,500 head of cattle from Utah. They were among the first settlers to put up hay for winter feed on the upper Yampa. In 1900, Thomas and William Morgan lived at Maybell, but in 1906, Thomas operated a livery stable (above) in Steamboat. At left is Preston King, who came into Colorado before 1880 as a civil engineer (working with the mines). Although he homesteaded 15 miles east of Dome Peak in the Flattops, by 1910 he had moved to Steamboat. (Above, Museum of Northwest Colorado; at left, Hildred Fogg.)

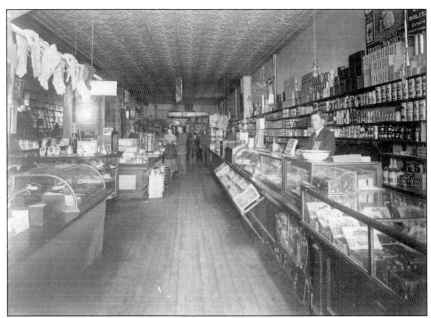

Archie and George Wither purchased their first store in Steamboat in 1901 and constructed a two-story building a few years later. The interior of the A&G Wither store is shown above with all the merchandise common to a general mercantile establishment—groceries (including canned goods), shoes, men's and women's clothing, dry goods, and hardware. The hay, grain, rock salt, and barbed wire were in the warehouse in back. Other early stores included Dunfield and Sons and J. W. Hugus. Competition, according to John Rolfe Burroughs, "did much to keep retail prices down, despite the high cost of freighting goods." Pictured below are Wither family children around 1906: Dorothy and George (standing) are children of Archie and Pearl Wither and John (in the carriage) is the son of George and Daisy Wither. (Both Tread of Pioneers Museum, Steamboat Springs, Colorado.)

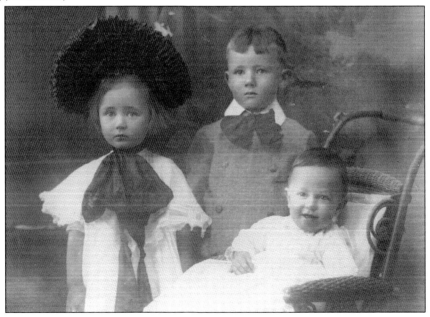

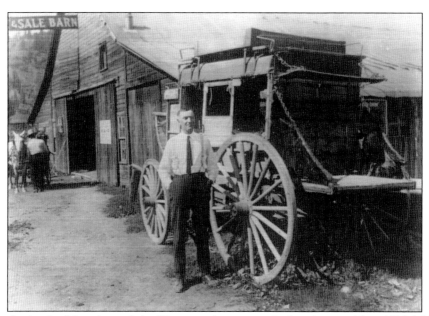

Charles Leckenby (above) stands by "the stage he came in" when he was 16 in 1896 (although one source states he came with his brother Harley using a burro). Harley (Hiram) moved on to Mancos, then Tucson, but Charles stayed and seven years later owned the *Steamboat Pilot*. The *Pilot* was the first newspaper in northwestern Colorado (1885) and became a Democratic voice; the *Routt County Sentinel,* edited by John Weiskopf, espoused Republican views. Unfortunately, a 1909 fire in the adjacent livery stable destroyed back copies of the *Pilot*. A 1959 anniversary edition stated, "A desk, the subscription list, and a few fonts of type were all that was saved from the *Pilot*. For the next three weeks the *Pilot* was issued through the courtesy of the *Routt County Sentinel*." Below, Leckenby is seated between his two sons, Maurice and Albert. (Both Tread of Pioneers Museum, Steamboat Springs, Colorado.)

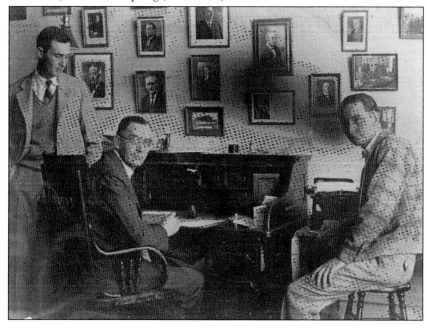

The first telephones in Routt County came in 1898 and connected the Cary Brothers Ranch (between Hayden and Craig), Norvell's Mercantile (in Hayden), and Byron T. Shelton's ranch (east of Hayden). Small, private companies operated until 1905 when regular telephone service was established. Pictured here are the switchboard and operators at Steamboat in 1923. (Tread of Pioneers Museum, Steamboat Springs, Colorado.)

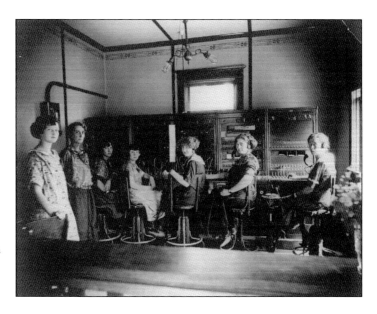

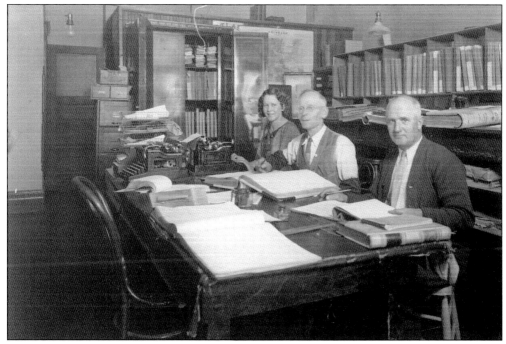

By 1910, brothers Edward and Wendell Zimmerman had an abstract office in Steamboat. The business continued in the family into the 1930s when Edward's daughters, Zelma and Muriel, worked as stenographers. A 1921 advertisement said, "A Zimmerman abstract is an asset to your property. Get one." This c. 1932 photograph shows, from left to right, Muriel, probably Wendell, and Edward. (Tread of Pioneers Museum, Steamboat Springs, Colorado.)

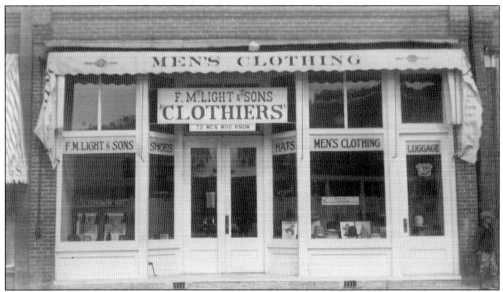

In 1905, F. M. "Frank" and Carrie Light left Ohio for Steamboat Springs, Colorado, bringing their seven children and seeking relief for Frank's asthma. After some consideration, Light decided to open a men's clothing store. He contracted a brick building and in November opened F. M. Light & Sons. He advertised, "We buy for cash. We sell for cash. We sell for less." Above is the early storefront; below is the interior in 1934 with Light's granddaughter Frances (left) and son Clarence ready to wait on customers. The Light family ventured into other businesses, including a candy store, a fox farm, raising Great Danes, selling automobiles, and a ladies wear/dry goods store. But the main business has always been F. M. Light & Sons, which has sold men's accoutrements for over 100 years in the same location. (Both F. M. Light & Sons.)

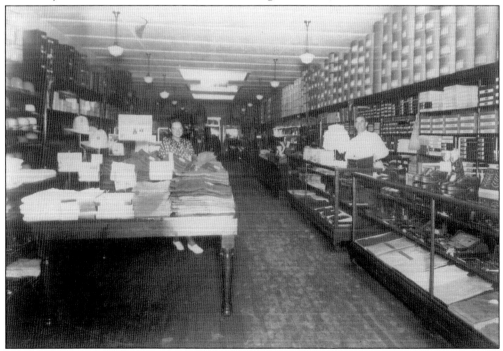

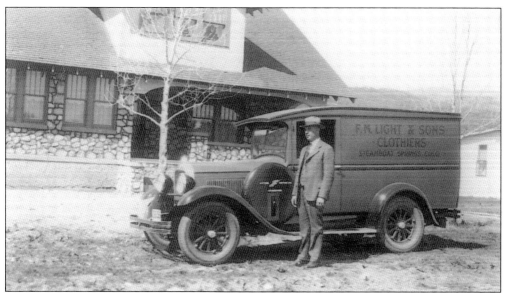

F. M. Light & Sons increased business (especially during the Depression) in two ways: Clarence Light, seen above, loaded his car with samples and visited ranchers and farmers in Wyoming and Colorado. Store employees then shipped the orders to many remote locations. Below, Light family employees put up dozens of roadside signs (yellow background with black letters) encouraging travelers to stop in Steamboat Springs to shop. In 1948, the store received this postcard from "A Texas Tourist," "In all of my traveling from Texas to Yellowstone, down thru Utah, Grand Canyon, and back to Mesa Verde, I have never observed any more persistent advertising than yours! The last one saying turn around if we missed you! . . . You deserve all the trade you get!!" (Both F. M. Light & Sons.)

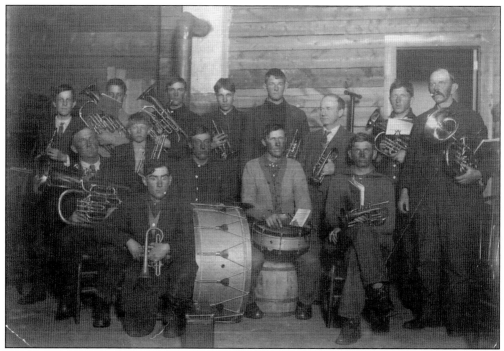

Rivalry between Steamboat Springs and other communities along the Yampa River grew in part because of the differences in background. Many in Yampa were coal miners of eastern European origin. However, this 1910 Yampa band would meet Steamboat people coming in on the train, escort them to "the grove," and provide a chicken dinner. (Hildred Fogg.)

The Congregational church in Yampa was organized in 1902 after a "wonderful revival." James Norvell donated the bell and preached fire-and-brimstone sermons. It is now nondenominational. Early Yampa ranchers, Lawrence "Doc" Marshall (right) and his brother Virgil, are pictured here in April 1921 ready to start for Meeker to roundup wild horses. (Linda Long.)

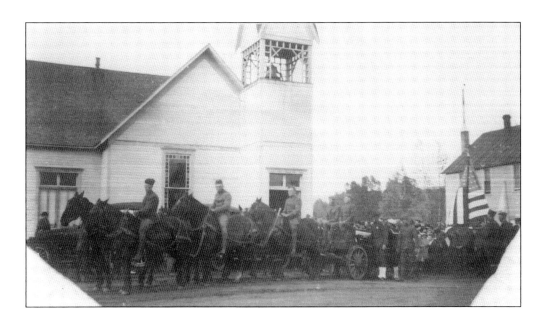

Participation in World War I initially was enthusiastic, and women's groups wrapped bandages and knitted socks. A total of 451 men enlisted from Routt County. Young men who died from the Elk and Yampa River valleys include Leo Hill, James Noyce, and Guy Utter (Steamboat); Harvey Bird, Willard Brown, Raymond Gretsinger, and Channing Reed (Yampa); George Klumker (Toponas); Raymond Whitmer (Clark); George Lawson (McGregor); and Zetto Stoddard (Bear River). Most of the men who died in France were buried in France, but some bodies were returned home. These photographs are of the funeral for Willard Brown, who died October 5, 1918, in France and was buried September 18, 1921, in Yampa. Doc Marshall is riding third in the cortege above. (Both Linda Long.)

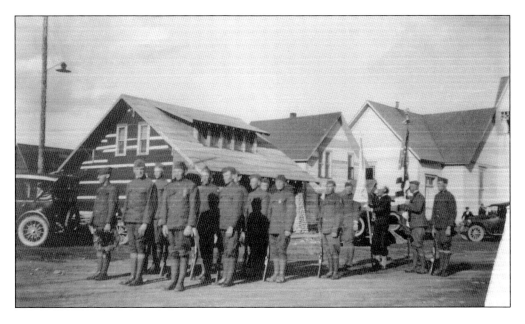

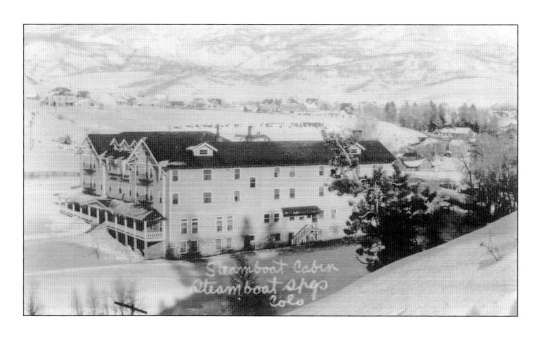

With the arrival of the railroad in December 1908, Steamboat townspeople readied themselves for a large influx of tourists. The most ambitious project was the Steamboat Cabin Hotel (above), located north of the river east of the train depot (below). The massive hotel had 100 guest rooms (but only four bathrooms) and became an integral part of the community. For example, at Winter Carnival in 1917, the grand parade began at the Cabin Hotel and continued to the ski course. Then a reception for the queen and the six maids of honor was held at the hotel. Dances were held at the Cabin Hotel and the Armory both evenings, with the coronation of the queen at the Cabin Hotel on Friday night. (Above, Museum of Northwest Colorado; below, Hayden Heritage Center.)

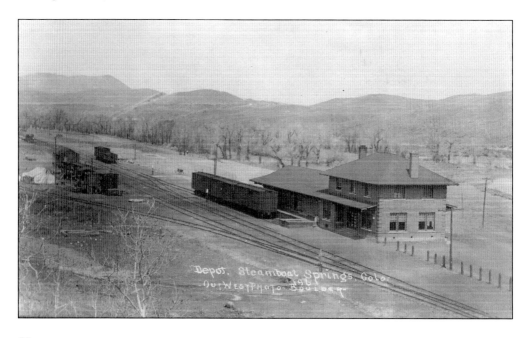

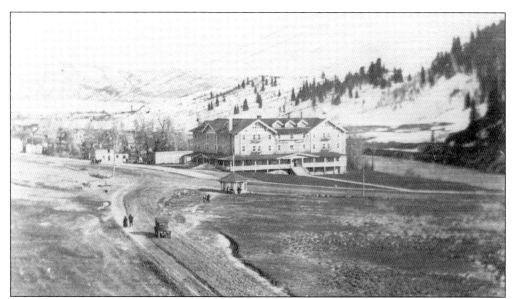

Summer visitors were encouraged to stay at the Cabin Hotel. In 1910, William Weston of Denver described three "drinking springs" very near the Cabin Hotel: the Heron, Bubbling, and Soda Springs (below). Analysis of chemicals in the water of each were printed. He also touted the "external uses and virtues" of the springs supplying the new bathhouse and open air pool. Nevertheless, the Cabin Hotel was seldom full. It changed hands several times, closed for some periods, and then reopened in 1937 for a stock-growers convention. On January 24, 1939, flames were reported at 11:45 a.m.; an hour later, two brick chimneys were all that was left standing. Two people died in the fire (out of 32 permanent residents), and almost all personal belongings were lost. (Above, Hayden Heritage Center; below, Tread of Pioneers Museum, Steamboat Springs, Colorado.)

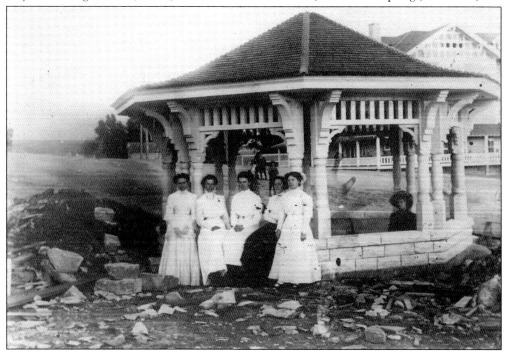

Before coming to Steamboat in 1932, H. W. Gossard, at left, made a fortune in women's brassieres and girdles from his headquarters in Chicago. His front-lacing corset revolutionized the industry worldwide. In Steamboat, he promoted the mineral spring/spa dream long held by others; early Steamboat bathing beauties are seen below. Most important in Gossard's mind was Lithia Spring. As early as 1890, physicians ascribed numerous cures to Lithia water. They used this natural diuretic to treat kidney problems and claimed it was a general aphrodisiac. Today lithium is used by mental health professionals. Gossard was also the primary proponent of the "mile of roses" (interspersed with native columbine) along Lincoln Avenue, but winter snows dampened shop owners' desires to tend the bushes year after year. (Both Tread of Pioneers Museum, Steamboat Springs, Colorado.)

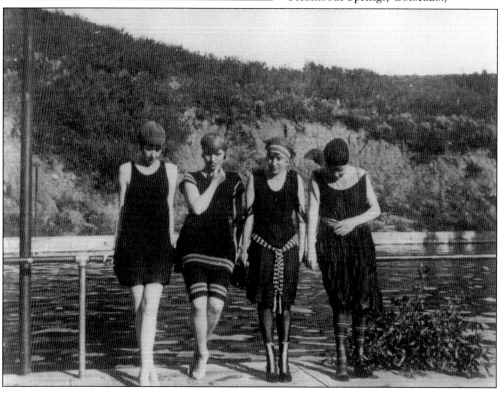

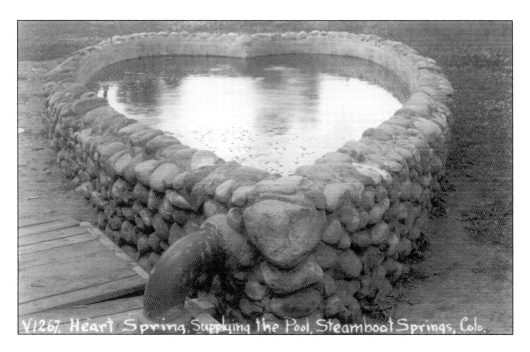

V1267. Heart Spring, Supplying the Pool, Steamboat Springs, Colo.

Clarence Light described Steamboat's 1905 bathhouse as "a frame building operated by Mr. Baird." Light said, "Of course, it was the same spring we have today—the same good warm water. Baths ordinarily were 25 cents and patrons furnished their own towel and soap." F. M. Light, however, arranged a special deal for his family and bought 1,000 tickets for $100. In 1909, a new bathhouse was erected, at a cost of $30,000. It had private pools, showers, tub baths, rubbing slabs, cooling rooms, parlors, a barbershop, and 140 dressing rooms. The Heart Spring, seen above, originally built in 1887 by James Crawford, supplied water for the pool, seen below in 1934. (Above, F. M. Light & Sons; below, Museum of Northwest Colorado.)

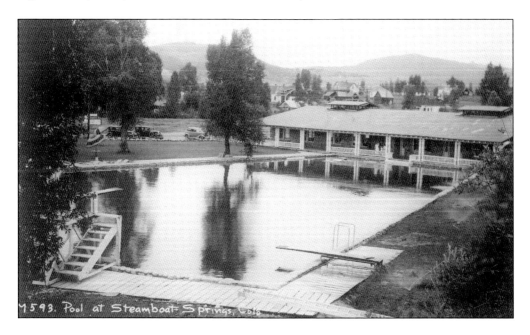

M593. Pool at Steamboat Springs, Colo.

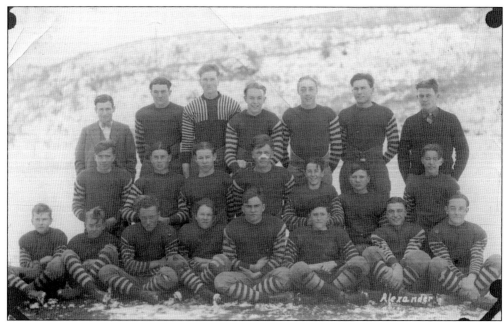

Athletics played a prominent role in early Routt and Moffat Counties. Above is a Steamboat Springs football team in the 1920s. Below, Clifford "Bud" Hurd (right), who listed himself in the 1930 census as "pugilist [in the] boxing ring" is shown with trainer Charles Caustin (center) in Chicago. Best known around Steamboat as a game warden who would first warn then fine only if an offence was repeated, Hurd worked with horses in his teens, traveled to Chicago to study art, and spent two summers on the professional boxing circuit. During the Great Depression, he sold coal from his one-man mine. He worked for the Forest Service, loved photography, and helped create the Hahn's Peak Historical Society. (Above, Hayden Heritage Center; below, Museum of Northwest Colorado.)

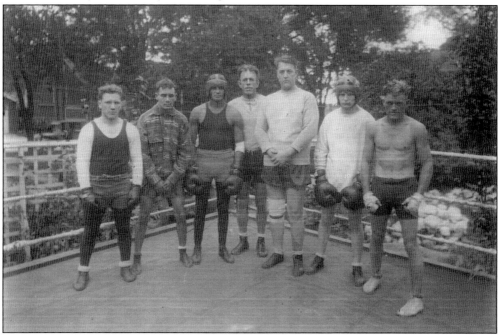

For five decades, Dr. Frederick E. Willett tended the ill and broken of Steamboat and surrounding communities. By sleigh or on horseback, he brought medicine and hope. Rancher John Sandelin said, "I don't think a greater man has come to this country." Willett served even when payment was unlikely, and what he did save was given, upon his death in 1970, to Routt Memorial Hospital. (Tread of Pioneers Museum, Steamboat Springs, Colorado.)

John "Doc" Utterback was a veterinarian (shown here with a totally unidentified cow part) and politician (county commissioner). After his death, his house was donated to the historical society and, in October 1997, was moved to its present location and connected to the Edward Zimmerman house. Today the two serve as the Tread of Pioneers Museum. (Tread of Pioneers Museum, Steamboat Springs, Colorado.)

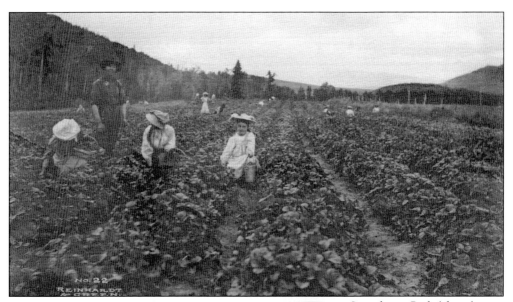

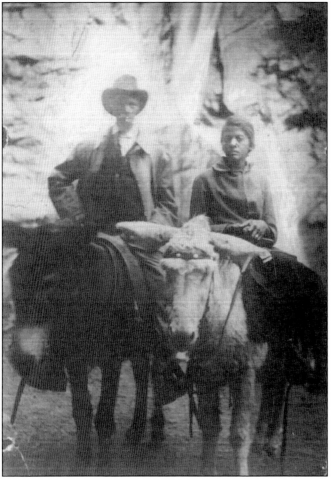

Strawberry Park (above) was once home to Daisy Anderson. Born Daisy Graham, at age 21, she married Robert Anderson, age 79, a former slave, Union soldier, and buffalo soldier in the Native American campaign. Financial success came to Anderson as a farmer in Nebraska, so he and his new bride (at left) toured extensively. Widowed after eight years, Daisy moved to Steamboat to live with her sister Mae Williams. They raised poultry, grew thousands of strawberries, and ran a restaurant. In a 1998 interview with Noah Adams of NPR, she said of Anderson, "Once in a while, I dream about him now. And it's a beautiful dream." She died at 97, the oldest of three surviving widows of Civil War veterans. (Above, Tread of Pioneers Museum, Steamboat Springs, Colorado; at left, *From Slavery to Affluence: Memoirs of Robert Anderson, Ex-Slave*.)

Although called the Antler's Hotel, this is not the famous Antlers Hotel along the stage route. This was the first hotel in Yampa and the residence of Ira Van Camp, who kept a livery stable and provided accommodations for stage riders. Note that the building has a sod roof. In the 1970s, owner Mildred Pidcock removed the sod and replaced it with tin. (Hildred Fogg.)

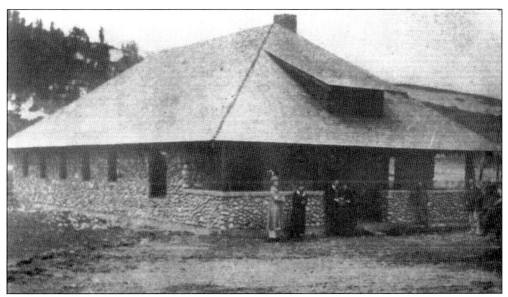

Appointed by the local Sportsmen's Club to raise funds for a fish hatchery, Arthur E. Gumprecht and R. M. Smith secured subscriptions from 102 individuals and businesses ($2.50–$100) to erect this stone building on the Yampa River. Gumprecht was contractor. By April 1921, red-spotted brook trout were being raised to replenish populations in local rivers. The *Routt County Sentinel* announced: "Baby Trout Well Worth Watching." (Museum of Northwest Colorado.)

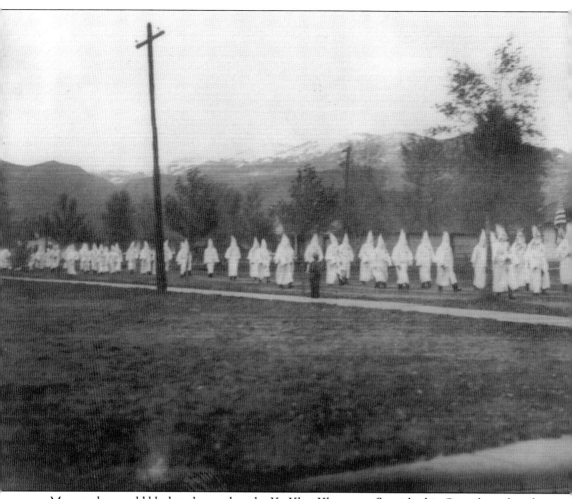

Many today would blush to know that the Ku Klux Klan once flourished in Steamboat, but the KKK's purpose was not to intimidate the few black people in Routt County. Rather they were bent on ridding the area of immigrants from Eastern Europe. Fortunately an unsympathetic city council passed the following ordinance on May 9, 1925: "It shall be unlawful for any person, at any time, to parade or march or travel on foot or in any automobile or other vehicle or otherwise, on any street, avenue, alley or public place within the town of Steamboat Springs, Colorado, with his or her face masked or covered or hooded or hidden, in whole or in part, and so that he may not be known or identified." Any person violating this ordinance could be fined from $10 to $100 per infraction. (Tread of Pioneers Museum, Steamboat Springs, Colorado.)

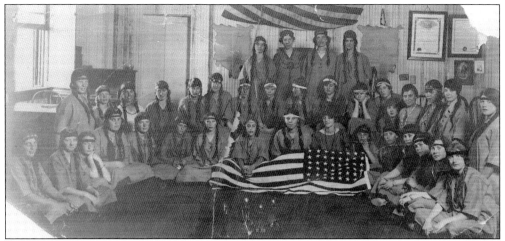

About 1914, Camp Fire Girls (a sister organization of the Boy Scouts of America) were organized in Yampa, Hayden, and Steamboat. The group (above) may be the June 1915 grand council where the three camps competed for "a beautiful silk American flag." The Hayden girls won but immediately presented the flag to their Steamboat hosts. Ellen Groesbeck and Grace Leckenby were early leaders. Note the Native American attire for the girls. (Tread of Pioneers Museum, Steamboat Springs, Colorado.)

Although Steamboat is more commonly known for its ski clubs, some of the women of the town formed a crochet club, shown here about 1955. Many national magazines (for example, *Aunt Martha's Workbasket, Home and Needlecraft, for Pleasure and Profit*) published crochet, knitting, and tatting instructions or provided iron-on transfers for embroidery, which the women then used to beautify their homes. (Tread of Pioneers Museum, Steamboat Springs, Colorado.)

97

The education of children was important for Steamboat Springs residents. Above, the girls in the second-grade class in 1928 are dressed for a special spring program (possibly May Day); Annabeth Light is at far left, while the others are unidentified. By the 1951–1952 school year, the classroom below had a playhouse for the children, complete with potted plant in the window to water. (Above, Annabeth Lockhart; below, Steamboat Springs High School.)

During World War II, the worry for hometown boys in the military in Europe or the Pacific was allayed a bit by the community interest in high school activities. Above, about 1943–1944, are the cheerleaders, from left to right, Doris Birkett, Billie Hay, Barbara Paulson, and Dorothy Wegeman. The girls' sailor costumes reflect a student body known as Steamboat Springs Sailors. Below, the Homecoming royalty for 1942 are, from left to right, Lu Waggnor, Dorothy Wegeman (queen), and Marlene Crawford, twin to Marvin Crawford, who helped design trails on Storm Mountain. (Both Hildred Fogg.)

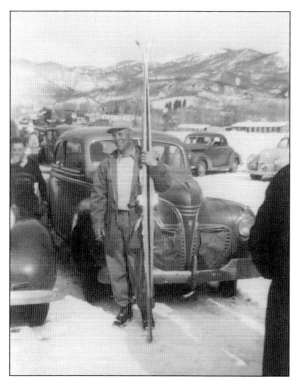

The man at left has been identified as Art Torkle (pictured here during World War II), but it is more likely his brother Torger. In 1943 and 1944, Camp Hale was built near Leadville to train the 10th Mountain Division. Military personnel often came to Steamboat to ski on the weekends and participated in the 1943 and 1944 Winter Carnivals. Torger won the Merrill Trophy and Class A Championship in 1944. He died in Italy in 1945. Below is a 1945 dance in the streets of Steamboat. Celebrations in many parts of the United States were muted when VE Day was announced (because sons were still dying in the Pacific), but VJ Day was celebrated all across the nation with street dances. (At left, Hildred Fogg; below, Tread of Pioneers Museum, Steamboat Springs, Colorado.)

Evelyn Pidcock of Yampa never drove a car. In 1933, at age 19, she checked her trapline, then on Sundays walked the 20 miles to church; that year she walked 4,042 miles total. A round-trip from Yampa to Trappers Lake in 1957 began at 6:00 a.m. and ended about 11:00 p.m.—she hiked 58 miles. Of a 1976 overnighter to the top of Pinnacle Peak, she remembered the "beautiful sight with the town lights of Yampa." (Hildred Fogg.)

When the Four-Mile Bridge was to be replaced to allow for heavier farm-equipment, many thought it could not be moved in one piece. Built in 1901 and on the National Register of Historic Places, it was the oldest bridge in Routt County. A plan was formulated, the bridge was moved, and strangely it rests today on a hilltop north of Route 40. It is now the proverbial "bridge to nowhere." (Raymond Gray.)

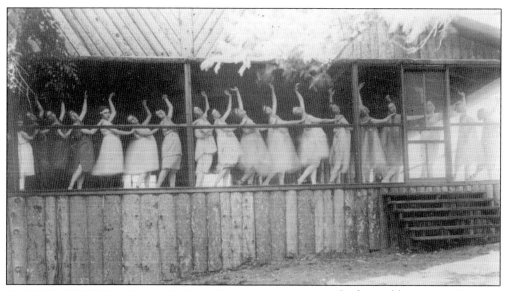

Such notable actors as Lee Remick, Julie Harris, and Dustin Hoffman first grew wings at a little clearing in Strawberry Park known as the Perry-Mansfield Performing Arts School and Camp. In 1913, Charlotte Perry (1889–1985) and Portia Mansfield (1887–1978) began a summer dance and drama camp near Nederland. They found this location too remote, so looked for a new home near Oak Creek, where Perry's brother owned a coal mine. However, concerns that the wood nymphs would be too great a distraction to the miners prompted a move to Steamboat. Above is an early group of girls on the porch of the 1880 homestead cabin called the "Cabeen." At left are Perry (left) and Mansfield in the 1960s. Each year, students arrive to study dance, painting, and acting at the nation's oldest performing arts school and camp. (At left, photograph by T. Ray Faulkner, both courtesy Perry-Mansfield School.)

So much in Steamboat is focused on snow sports, but Steamboat Springs High School teams also won 20 state championships: five in track, six in wrestling, and nine in other sports. The name of Kelly Meek will long be remembered as the coach of many great track and basketball teams. So will the name of Carl Ramunno (right), who built a one-man dynasty in wrestling. His teams won league championships 17 times, with six state championships and second place in state six additional times. In 1988, Coach Ramunno received nationwide honors as wrestling Coach of the Year. Jim Stanko stated that Ramunno's greatness came not merely from winning matches but from changing lives. He would take a boy aside, even a non-wrestler, and redirect him toward worthy goals. (Both Steamboat Springs High School.)

Thomas Edison was only 50 miles from Steamboat Springs when he gazed at the incandescent stars and dreamed of electrified cities, so claimed John Rolfe Burroughs. Steamboat received electricity in 1901 (with the power plant and boiler hauled by wagon from Wolcott), only 19 years after London and New York City became the first lighted cities. Rural Routt County did not begin to get electricity until 1941. Above is the Yampa Valley Electric Association board at the 1956 dedication of their new building in Steamboat, which includes, from left to right, (first row) Ray Lyons, George Simonton, Ora Harris, Otto Gumprecht, and O. Marion Jones; (second row) Loy Ardrey, John Sherman, George Cook, and I. G. Arnold. Mary Brunner, seen below, was also a board member. Note the four men wearing neckties with Willy Wirehand on them (Rural Electric Association's takeoff on Reddy Kilowatt). (Above, Museum of Northwest Colorado; below, Tread of Pioneers Museum, Steamboat Springs, Colorado.)

Four

FARMING AND RANCHING BETWEEN SNOWSTORMS

It can freeze in July at Steamboat. It can snow any month of the year. Raymond Gray, well-known Elk River rancher, wrote, "Routt County is a difficult area to ranch in, as the winters are very long and harsh. At this 6,660 foot elevation, we get up to 225 inches of snow. It is hell on men and horses. The only thing that keeps us here is the beautiful summers. We can always be sure of a decent crop too."

Early cattlemen, along with most of the deer and Utes, left the high country to winter beside the still waters of the Green and Colorado Rivers. Some early residents of the towns also migrated, but most stayed put. Even when the snow is higher than the fences and one-story buildings are toboggan ramps, most winter days are sunny.

Perhaps the reason people stay derives from a legendary curse of the recalcitrant Ute chief, Colorow. As 1,400 Utes were forced across the Green River into Utah in 1881, he supposedly said, "Those who come to the Yampa Valley to live will never be able to leave. If they bring riches to the valley, they'll leave them here; and they'll never find lasting happiness here. If they do succeed in leaving the valley, they'll be forced to return." Many who do come to the Yampa stay, and many who do not stay, long to return.

By 1900, domestic livestock had left the mountain pastures depleted and eroding, and the cattlemen themselves began calling for federal restrictions on grazing. A Hayden-based rancher and lawyer, Farrington Carpenter, above all others, was influential in writing the laws and regulations for the 1934 Taylor Grazing Act. Then he led the agency that, to a degree, restored millions of acres. The wildlife, the profusion of flowers, and the extensive forests that today make these mountains and valleys serene are evidence that man can stay his hand and allow the land to heal.

With open-range grazing, cattle from various ranches were often mixed together so branding was imperative. John Rolfe Burroughs published a photograph of a cattle roundup about 1910 in Lily Park; at least four different brands can be seen on the cattle. Above, brothers John and Val Brunner of Steamboat are branding in 1921. Dehorning, if done when calves are young, is bloody but not massively traumatic. At left, Doc and Floyd Marshall of Yampa are dehorning a large Hereford in the 1920s. (Above, Tread of Pioneers Museum, Steamboat Springs, Colorado; at left, Linda Long.)

Cattle infested with blue lice and grubs were not as marketable as cattle free of arthropods. By 1941, cattle were often treated with insecticides. From left to right, neighbors Floyd Baalhorn, Henry Robinson, Walter Robinson, Don ?, George Woodcock, and George Johnson are running cattle through an insecticide dipping vat on May 10, 1941. (Raymond Gray.)

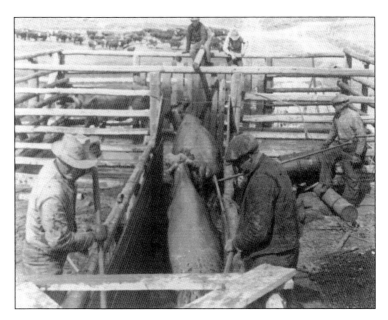

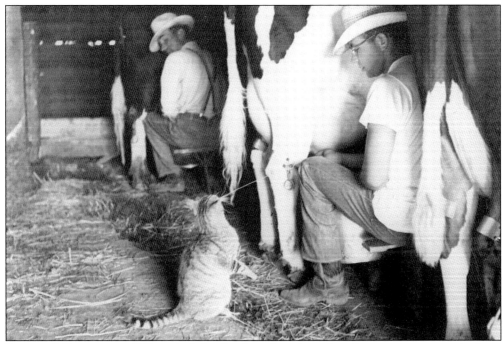

Raymond Gray wrote, "What do I think of ranching? . . . It is hectic at times in the busy season, but one is always his own boss. We never work on Sundays except to feed the stock and do chores." However, milking is twice a day, seven days a week, 365 days a year, as illustrated here in the Baldwin barn south of the Yampa River. (Tread of Pioneers Museum, Steamboat Springs, Colorado.)

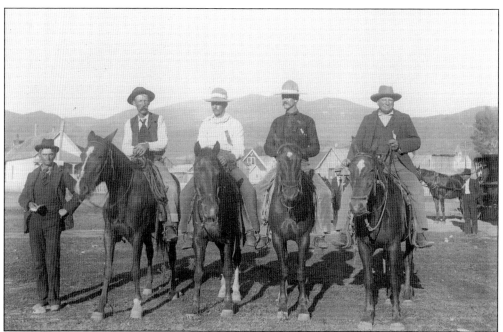

In 1903, the Steamboat city fathers found it necessary to pass an ordinance making it illegal to race horses or have a bucking contest on the streets on Sunday mornings. (The cowboys above are unidentified.) Early rodeos were simply natural outgrowths of working with range cattle, impromptu affairs with people circling their horses (or later cars) around a clearing. Because there were no holding chutes, the horses would be thrown to the ground, blindfolded and saddled, and then mounted. When the blindfold came off, the horse would be up and bucking until subdued or the rider thrown, as was Lawrence "Tuffy" Wren (below). John Rolfe Burroughs spells Lawrence's nickname as "Toughy," though. (Above, Museum of Northwest Colorado; below, Hildred Fogg.)

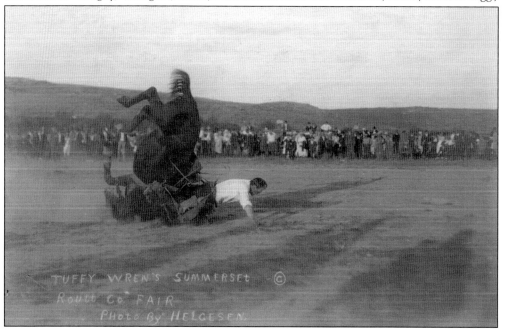

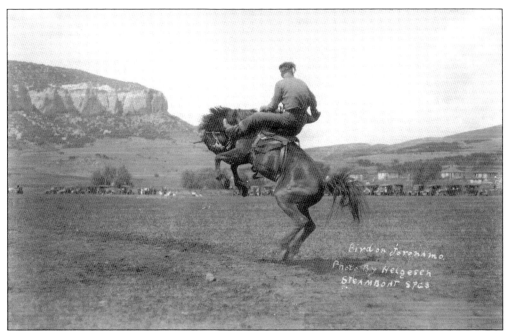

Pictured here at Mount Harris is another local cowboy named Bird (probably George). George's grandfather William, with grown sons Tom and Albert, staked out homesteads in Egeria (now Yampa). So many Bird relative lived in Yampa that it was sometimes called "Bird Town." William's son Frank guided Theodore Roosevelt on a hunt in the Flattops. (Hildred Fogg.)

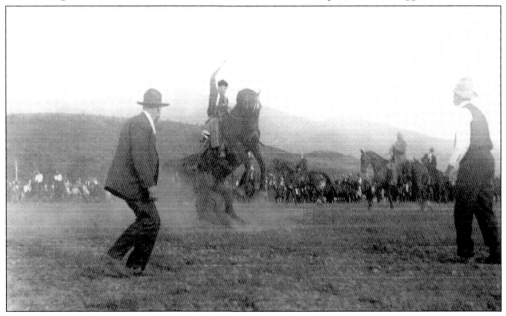

Many of the early horses were as famous as the best riders. Walter Long is seen here on a horse named Pin Ears. Pin Ears, a bay gelding owned by Long, was particularly bad. At home, he was gentle, even around children. At rodeo time, though, he knew how to perform. When a man was thrown, Pin Ears would immediately begin "pawing" or stomping his former rider into the ground. He was known to have killed three men. (Ellis collection.)

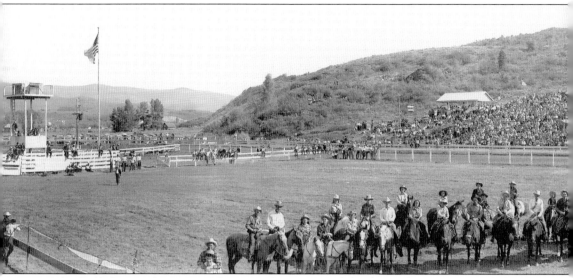

John Rolfe Burroughs wrote, "I have vivid memories of the first rodeo I ever attended. It was on Game and Fish Day, the date being September 3rd, 1909. I was seven years old at the time. The bucking and the races were held on the flat south of the Yampa River. . . . There wasn't a grandstand or a corral or fence in sight." Old-timers assembled, read historical essays, and provided

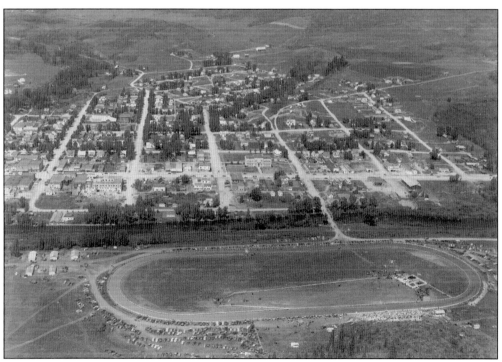

The rodeo grounds are seen here in an aerial shot a few years later in the 1950s. (Museum of Northwest Colorado.)

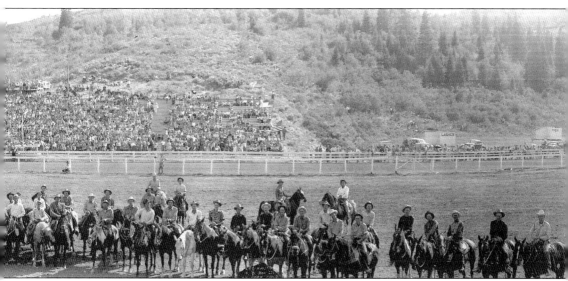

a free barbeque of elk, deer, and "hundreds of mountain trout." The bucking contests and other equestrian events were held in the afternoon. Pictured here are 1947 rodeo participants lined up for their photograph. (Tread of Pioneers Museum, Steamboat Springs, Colorado.)

Doris Evangeline Simmons from Clark (later married to Doc Utterback) shows a young Hereford bull in the 1930s, the end result of much hard work. Many residents showed livestock in the Routt County Fair at Hayden (the first was held in 1914), the state fair, or the National Western Stock Show in Denver. (Tread of Pioneers Museum, Steamboat Springs, Colorado.)

Margaret Brown

In 1915, Margaret Duncan Brown and her banker husband, Thornton, quit town and began sheep ranching on Elk River. Three years later he died, leaving Margaret with the sheep and debts; she lived by herself for 47 years. The diary she kept became the basis for her book, *The Shepherdess of Elk River Valley*, and she won a *Reader's Digest* First Person Award in September 1958. For *Reader's Digest* she wrote, "There were about 300 in the flock, a small bunch for this Colorado country—but they represented my only hope of paying out on my ranch." She learned that perseverance and determination were not enough. Instead, she found help from others—a sheep horse named Rex, her fawn-colored collie Laddie, and an itinerant sheepherder/trapper named Rube. (Both Clark Post Office.)

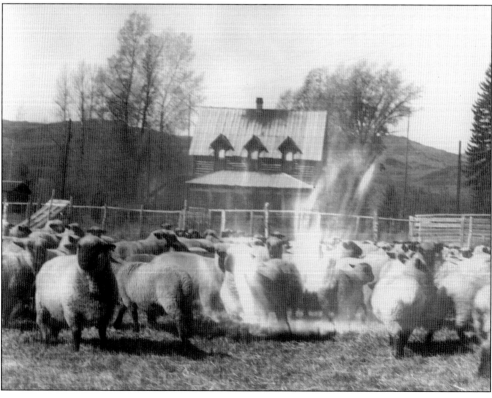

Pictured above is Margaret Brown's house, which still stands. When her husband died, she was asked, "Why don't you do something you're fitted for, like getting married again or teaching school?" After Rube helped her save the ewes and lambs in a typical Colorado spring snowstorm, and after they discussed references to sheep in the Bible, Brown wrote for Rube, "In those celestial pastures / Beside still waters deep, / May the eternal future find me / With a little bunch of sheep." Below, the Alfred boys (possibly Lawrence and Bruce), at their homestead in Yampa around 1920, are bottle-feeding bum lambs, a good source of income if the children can keep the lambs alive. (Above, photograph by David Ellis; below, Hildred Fogg.)

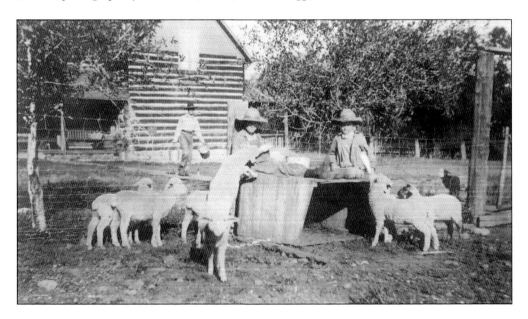

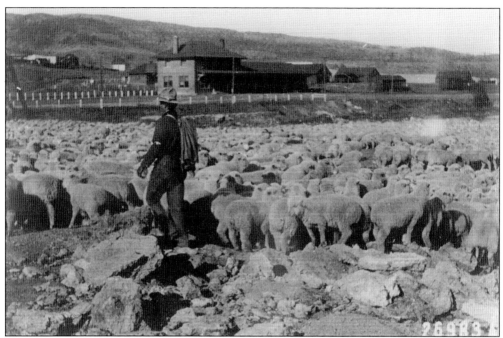

Unfenced public domain and railroad lands were fair game for pasturing cattle and sheep—fair game until sheep men began to move into Colorado. In 1895, a rumor of invading sheep was enough to assemble 200 cowboys to bar the way. Over the years, a few Mexican sheepherders were killed and hundreds of sheep were bludgeoned. John Rolfe Burroughs wrote that with "Steamboat Springs being a cow town, no host in his right mind would think of insulting his guests by serving lamb chops or roast leg of lamb." However, by 1911, sheep were trailed to the railhead at Steamboat. Pictured above, around September 20, 1915, is a herd belonging to Boyer brothers of Rock Springs, Wyoming. Below, George and Emma Salisbury move their portable sheep camp. The Seaversons from Rawlins and the J. O. Sheep Company also pastured sheep at Hahn's Peak in the 1940s. (Above, Tread of Pioneers Museum, Steamboat Springs, Colorado; below Janice Kay.)

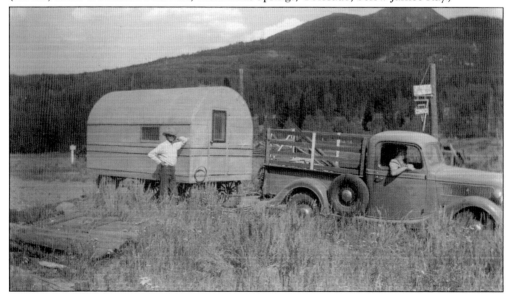

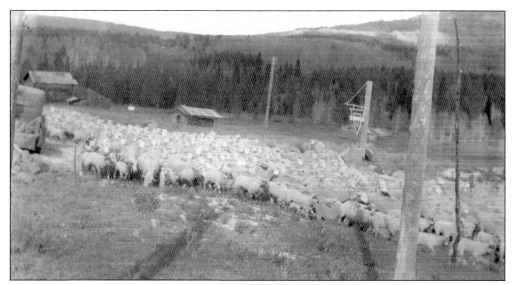

The Forest Service got involved as referee and decided some sheep could use the Elkhead and Park Ranges. Gradually cowmen and sheep men learned to tolerate each other. The Forest Service was accused of favoring sheep men, but in reality, grazing permits reduced the number of both cattle and sheep. One of the large sheep outfits was the Cow Creek Sheep Company, seen here around 1940 with a flock on the trail near Columbine. (Janice Kay.)

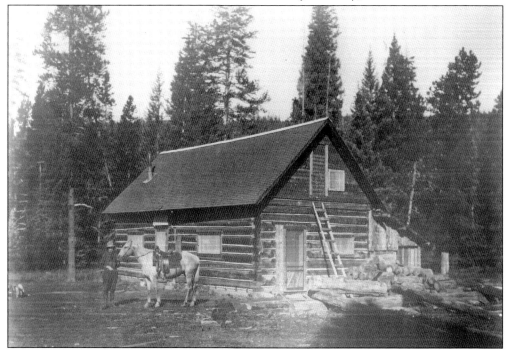

The Forest Service Seed House, built in 1910, was only used one summer. Ray Peck remembered "a large number of spruce and [lodgepole] pine cones were gathered," then laid on large wooden screens by the fire. When warm, the cones released their seeds, which were packaged for distribution to other forests. Later the Seed House was used as a ranger station. It is pictured here around 1918 with George Hughes and his horse. (Hayden Heritage Center.)

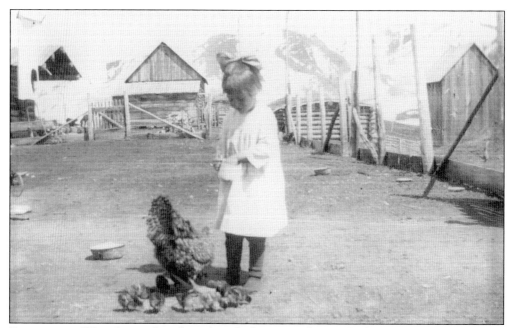

Even very small hands were kept busy; here little Mary Whitmer feeds a mother hen and chicks at Clark in the early 1920s. An extreme example of child labor is Marcellus "Celly" Merrill's memories of his family's struggle to eke out a living at Steamboat even before the Great Depression. However, he found time to read 20 volumes of *Hawkins Electrical Guides* by kerosene lamp and, as an adult, patented dozens of inventions, including a floating (hollow) fishing hook and various components for the aerospace industry. (Clark Post Office.)

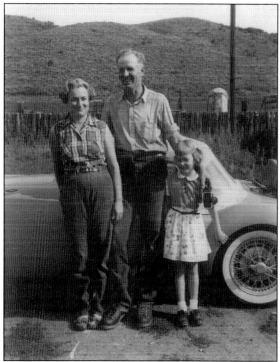

Raymond Gray was born in Nebraska in 1917 and, during the dust bowl days of the 1930s, saw "chickens go to roost in the middle of the day." The family came to Steamboat in 1939 and thought it looked like an oasis. They rented farms until 1946 when they had enough money to buy one. Pictured here are Raymond; his wife, Alice; and their daughter Marsha. He said, "We ran the ranch as a family unit." (Raymond Gray.)

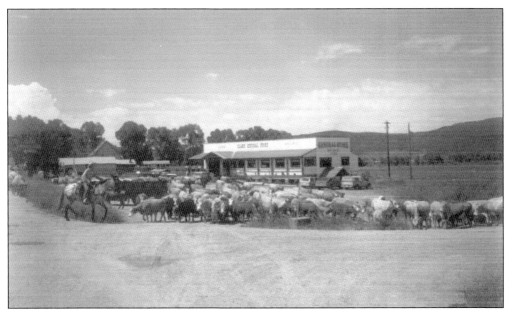

In 1965, Raymond Gray and 16 other cattlemen formed the Elk River Grazing Association. They purchased the Hunt Land and Cattle Company acreage along the upper Elk River and pastured cattle below Sand Mountain. Raymond Gray's personal check for $10 put an option on the 3,700-acre Hunt property (the FHA loan was $322,330). Winfred Spangler was hired to run the ranch. Each year, about 1,500 steers and heifers were fattened on the ranch and adjacent Forest Service lease lands. Cattle were then trailed, as seen above in 1986 at Clark, to Steamboat Springs and shipped by rail to market. Pictured below is another product of Steamboat Springs's ranching tradition—square dancing on horseback. (Above, Clark Post Office; below, Tread of Pioneers Museum, Steamboat Springs, Colorado.)

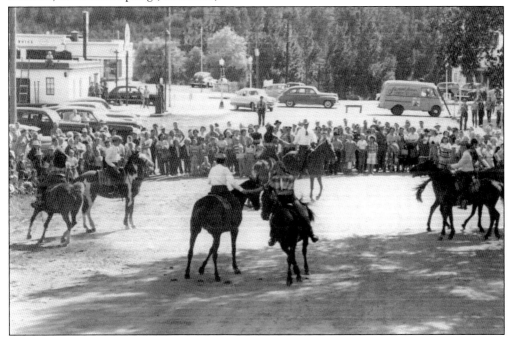

William and Kate Crowner came to Colorado around 1885 and settled about five miles south of Toponas. Pictured at left are their children, Helen, Will, and Earl (seated) around 1895. Forty-five years later, Earl Crowner and John Holden were important lettuce growers in Upper Egeria Park. From 1920 to the 1950s, lettuce, spinach, peas, and cauliflower, ideal crops for the short, 30-day growing season, were raised in Toponas and Yampa. With more than 2,500 acres in cultivation, Routt County contributed significantly to Colorado's ranking as second in lettuce production nationwide until World War II. One fundamental requirement for the industry was the ability to produce and store massive amounts of winter ice (sheds below) for use in cooling lettuce during summer shipment on the railroad. Such railcars packed with ice and head lettuce gave rise to the name "iceberg lettuce." (Both Hildred Fogg.)

Toponas, "the crouching lion," is the Ute name of one of the many volcanic necks (like the one seen in the background above) in this region. In the foreground is a lettuce field with an unidentified man. In 1927, the Eagle Packing Company, with B. H. Klatt as manager, shipped lettuce from the shed at Yampa, seen below. The Eagle Packing Company was committed to distributing only Colorado products, and Klatt was always willing to provide tips for his growers on how to better handle the lettuce. Lettuce was first commercially grown in Colorado in 1918 and first grown in Routt County in 1921. This industry, however, was ephemeral due mainly to a drop in market price during the Depression and the development of year-round truck farms in California and Arizona. (Both Hildred Fogg.)

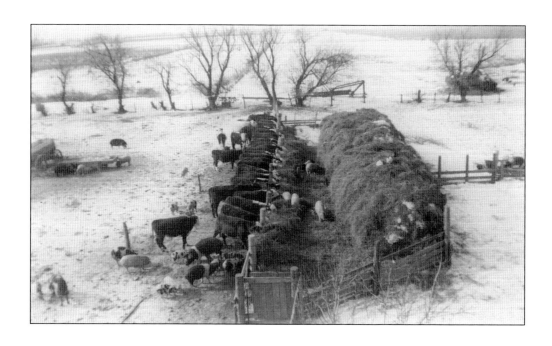

From the beginning, supplemental feed was necessary for cattle, sheep, and horses during the long winters in the high-elevation valleys around Steamboat Springs. In 1984, Raymond Gray told a reporter for the *Steamboat Pilot*, "Many winters I started hauling hay to the animals in November. Feeding them that way went on to the latter part of May. Some days I hauled up to 225 bales, but most days it was around three tons, handled twice." He added, "I've done that work in temperatures as low as -55 degrees, but that's rare." The photograph above is Gray's feeding setup on November 28, 1941. Below, Doc Marshall is using his team, Flossie and Buster, to feed cattle on his Finger Rock Ranch in the 1930s. (Above, Raymond Gray; below, Linda Long.)

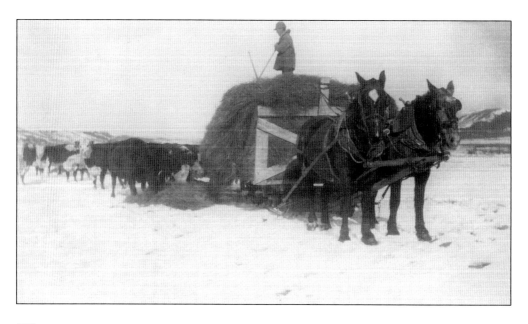

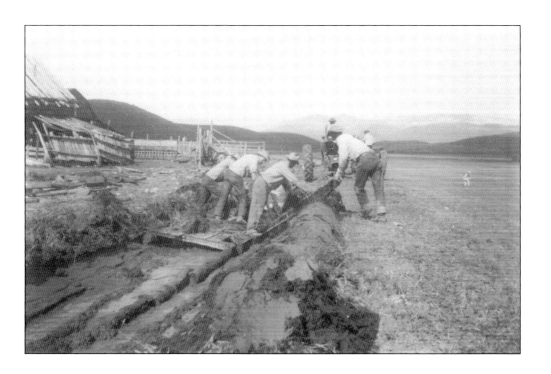

Although Steamboat ranchers received plenty of snow (some winters are called three-wire winters because the snow is as deep as the top wire on the fences), summer can be dry and irrigation is needed for pastures. Utilizing water from the Yampa and Elk Rivers and with extensive ditching, Routt County hay meadows are some of the best. Above, the ditch on Raymond Gray's ranch is being cleaned of grass, weeds, and silt, all of which impede the flow of water. Below, the Baalhorn and Gray haying crew is taking a lunch break. (Both Raymond Gray.)

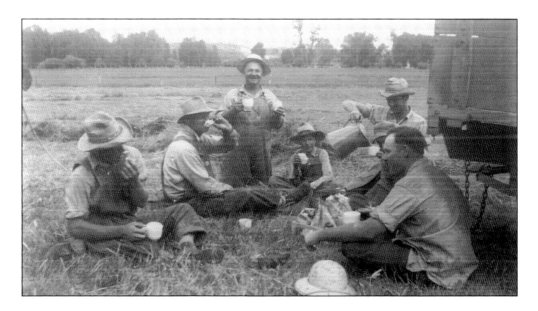

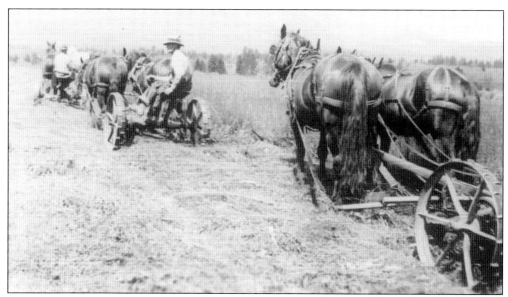

For millennia, hay was cut by hand with a sickle or scythe. By the early 20th century, horse-drawn mowing machines replaced most scythes. Bill Bedell (center) is part of a three-member mowing team near Hahn's Peak around 1926. A common swath was 5 feet wide, but sometimes mowers were 6, 7, or 8 feet. A man with a 5-foot mower arm could cut 10 acres in 10 hours; with a 6-foot arm, he could mow 12. (Clark Post Office.)

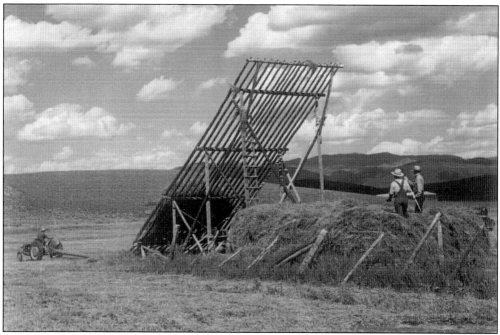

In the 1930s and 1940s, putting up hay required at least a four-man crew. Sometimes neighbors traded work, and at other times extra farmhands were hired and paid $1 to $2 per day plus room and board. Here the Gray/Baalhorn men use a slide stacker to begin a haystack in the mid-1940s. Many efficient homemade and factory-made stackers were used in the West. (Photograph by William Cusick; courtesy Raymond Gray.)

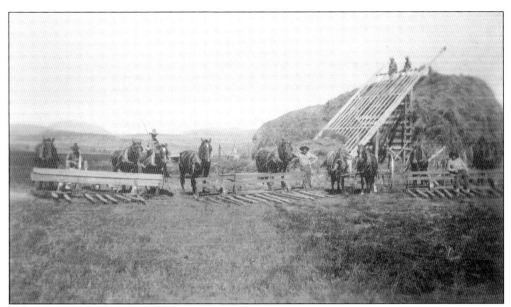

The most efficient use of a slide stacker was to have two men on the haystack moving hay into place, another man operating the stacker, and at least three running sweep or push rakes bringing hay to the stacker. Pictured above are three push rakes (with two horses each) and one sulky rake (pulled behind two horses) all in use at Doc Marshall's farm. The rakes drop a load of hay onto the teeth of the stacker, and then one or two horses (or later a tractor) pull a cable, seen below, or use a plunger to lift the hay to the top of the stack. Doc Marshall is on the stack, and Ed Jones is on the ground with the horse at the 21 Ranch at Burns in 1924. A crew this size could make five to seven stacks (10-12 tons each) in a day. (Both Linda Long.)

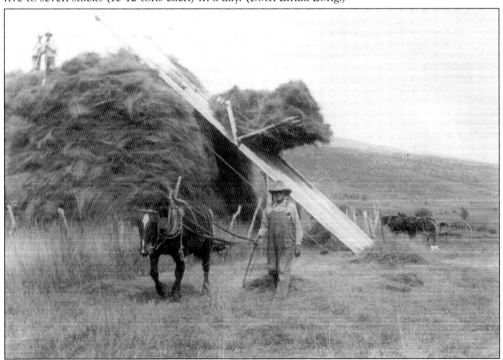

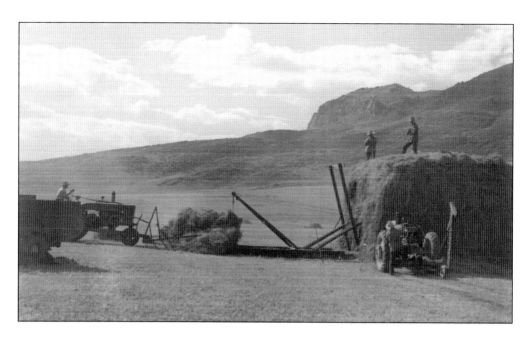

Haystacks in Steamboat Springs were also made with overshot stackers (sometimes called swing around or combination stackers) as seen here below Elk Mountain in the 1940s. With these stackers, the hay could be dumped at various points on the stack, and therefore fewer men were needed to reposition the hay. Here the men are using tractors to both load hay on the stacker and to lift the hay to the top. By the 1950s, horses were mostly replaced by tractors and hay was baled, not stacked loose. Today many Yampa and Elk River ranchers produce the huge, 800–1,500-pound, round bales that are more resistant to moisture. (Both photographs by William Cusick, courtesy Raymond Gray.)

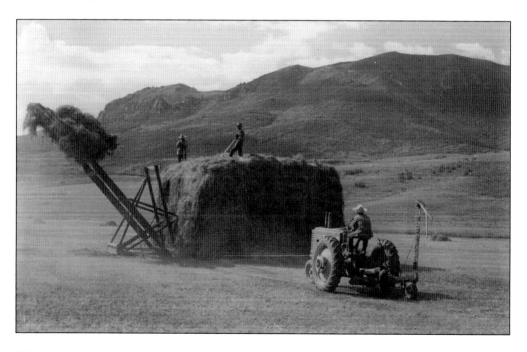

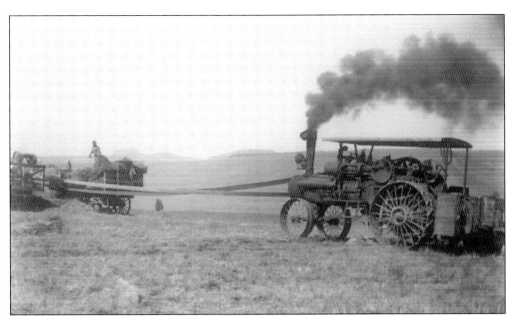

In the early 20th century, threshing oats in Routt County involved a threshing machine that was moved from farm to farm and a large crew that was served lunch or dinner. The oats had previously been cut, bundled, and put into shocks, allowing the grain to dry. When the machine arrived, horse-drawn wagons brought the bundles of oats to the thresher, which was powered by a 150-foot-long belt attached to a steam-driven tractor (above). As the grain moved through the threshing machine, the oats were beaten from the stalks and the straw was blown out of the machine into a large pile. The threshing crew (below) is on the Appel farm on Twentymile Road around 1925. (Above, Hildred Fogg; below, Tread of Pioneers Museum, Steamboat Springs, Colorado.)

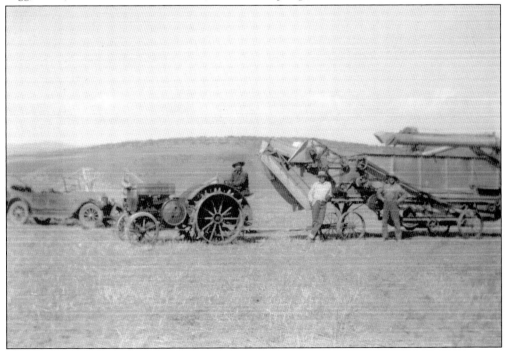

In 1988, Raymond Gray and his eight-year-old grandson, Nathan "Nate" Daughenbaugh, were checking fences in Long Gulch when a thunderstorm arose. They sought shelter in a nearby barn, where *Steamboat Pilot* reporter, Ross Dolan, snapped their photograph. (*Steamboat Pilot*.)

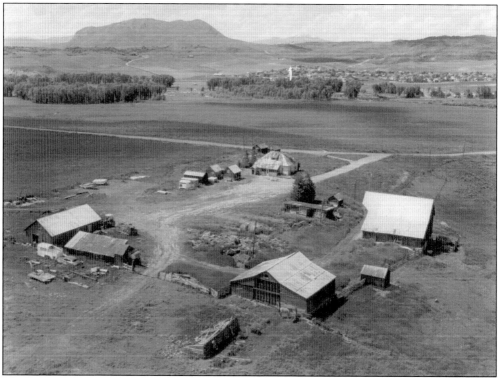

The Ute chief, Colorow, may have been right: those who come to the upper Yampa have a hard time leaving. Near Steamboat, there are six centennial farms (farms owned by one family for at least 100 years). Pictured is the Stanko headquarters, 3.5 miles west of town with Elk Mountain (Sleeping Giant) in the background. Peter Stanko Sr. bought land from Steamboat founder, James Crawford, then Peter Stanko Jr. and his wife, Natalie, worked it, as Jim Stanko and his wife, Joanne, do today. Other centennial farms include Monger, Hogge/Squire, Soash, Sandlin, and Sherrod. Also, the Boor-Redmond ranch at Toponas has been given Colorado Historic Ranch status. (Jim Stanko.)

When cloistered in nature's cathedral, on any one of a hundred mountain trails, it is easy to believe that Colorow's words were not a curse but a blessing. At Fish Creek Falls, seen at right, mountain-born waters plunge into a glacier-carved valley. Below in the 1920s, Doc Marshall (left) and his brother Virgil (right) pack in to mist-shrouded Upper Island Lake in the Flattops. From fertile valley to sheltered forest glen, and higher still on windswept tundra, every inch of this land is home to some living thing that like Steamboat residents, and like the Utes, has no desire to leave. (At right, Tread of Pioneers Museum, Steamboat Springs, Colorado; below, Linda Long.)

DISCOVER THOUSANDS OF LOCAL HISTORY BOOKS FEATURING MILLIONS OF VINTAGE IMAGES

Arcadia Publishing, the leading local history publisher in the United States, is committed to making history accessible and meaningful through publishing books that celebrate and preserve the heritage of America's people and places.

Find more books like this at
www.arcadiapublishing.com

Search for your hometown history, your old stomping grounds, and even your favorite sports team.

Consistent with our mission to preserve history on a local level, this book was printed in South Carolina on American-made paper and manufactured entirely in the United States. Products carrying the accredited Forest Stewardship Council (FSC) label are printed on 100 percent FSC-certified paper.

MADE IN THE USA